COMPLETING THE PICTURE

Completing the Picture

MATERIALS AND TECHNIQUES
OF TWENTY-SIX
PAINTINGS IN THE TATE GALLERY

THE TATE GALLERY

ISBN 0 905005 63 5
Published by order of the Trustees 1982
Copyright © 1982 The Tate Gallery

Published by the Tate Gallery Publications Department,
Millbank, London SW1P 4RG
Designed by Caroline Johnston
Printed by The Hillingdon Press, Uxbridge, Middlesex

CONTENTS

cover
Sir William Orpen,
'The Model' 1911
53.9 × 69.2 (21¼ × 27¼)

Measurements are given in centimetres
followed by inches in brackets;
height precedes width.

FOREWORD

There are many ways of enjoying paintings; each aspect of a work has its own individual appeal. But the full appreciation of a painting depends on the ability to see it in its historical perspective and at the same time to understand the artist's intentions. These intentions have traditionally been communicated by utilising a limited range of materials in a surprising diversity of ways. A close study of an artist's technique – the particular diversity and order which he or she has employed to achieve a given image – will inevitably enhance the appreciation of both painter and painting.

The three dimensional process of creating a picture can be likened to a journey. The finished work, the destination, is inextricably associated with the means of arriving at that end. Indeed the pitfalls, landmarks, vehicular limitations and alterations in direction can often be illuminating and of as much general interest as the finished product.

Books of an art historical approach are legion; publications concerned with specific artists' techniques are all too few. This book has taken the work of twenty or so painters over the last two centuries and has attempted by means of case studies to add a new dimension to the enjoyment of painting in general. It is hoped that both painter and public will find something of interest in these pages.

The impetus for these essays came from preparations made for the exhibition of 'Paint and Painting' on the history of the artists' colourmen's trade to coincide with the 150th Anniversary of Winsor and Newton who have generously provided financial support for the exhibition and this publication.

Alan Bowness, *Director*

ACKNOWLEDGEMENTS

Acknowledgements are due to:
Winsor and Newton artists' colourmen
for their financial support;
The National Gallery Scientific Department
for their help with analysis; The Courtauld
Institute for some of the x-radiography;
The Tate Gallery Photographic Department;
The British and Modern Collections of the
Tate Gallery and Michael Compton for their
advice; and Victoria Todd for preparing the text.

Stephen Hackney, *General editor*

INTRODUCTION

The purpose of this book is to draw attention to the materials and techniques employed by a selection of well-known artists whose work is represented in the Tate Gallery. It takes the form of essays by members of the Conservation Department focusing attention on one specific painting, or group of paintings, to illustrate a particular technique. Each essay emphasizes a different aspect of the craft of painting, largely defined by the properties of the work under examination. The authors have approached their subjects in a variety of ways; some have speculated on the activities of the artist in his studio, others have taken the point of view of the conservator examining the finished work, and others have used the chosen painting as the basis on which to explore a wider field. In addition, the first essay is concerned with means of examination and methods of photography available to conservators, to indicate how the information in this book has been gathered. An attempt has been made to outline some of the general properties common to many paintings in order to explain the terms used (a glossary has been provided), and to avoid repetition in the text wherever possible. It is hoped that these essays will complement one another, encompassing a broad representation of the painter's craft and offering some insights into the discipline.

The information is largely drawn from Conservation Department Records and the examination of paintings by Conservation Department staff. Where extra material has been collected from published sources, references have been given. Most of the photographs are taken from either Tate Gallery Publications or Conservation Department files. Where pigments or media have been analysed this has been stated in the text giving due credit to the analysts involved. Inevitably with a small group of paintings the information cannot be comprehensive. It has to be remembered that the collection of this material is not the main priority of the Department and although many analytical techniques are available, it has not been possible to apply all of them on a systematic basis. Nevertheless, in the normal course of events, over a number of years many useful details have been accumulated both from careful observation of the works and from questionnaires sent to artists. It is hoped that the dissemination of some of this information will aid students, artists and others interested in the practice of painting seen here in some of its more successful forms.

The paintings selected have been chosen not only to cover a variety of materials and techniques but also to represent some of the better known works in the collection. By choosing outstanding examples we hope that the book will be both enjoyable and interesting. The paintings cover the period most fully represented in the collection of the Tate Gallery, that is, from the late eighteenth century to the present day. This is also the period in which new painting materials, and their commercial development by the artists' colourmen had the most effect on painting technique.

In the seventeenth century artists had to prepare nearly all their own supplies from the limited range of raw materials available. With the exception of a few pigments there had been little innovation and artists had to be entirely familiar with all

aspects of a well-tried craft of painting, hardly differing from that of the Old Masters' studios. They would need to know how to make stretchers, to prepare and prime their canvases, and all the intricacies of grinding their pigments in various oils and resins before they could even consider their application.

During the eighteenth and nineteenth century the artists' colourmen gradually assumed many of these duties, at first providing basic materials such as paints and stretchers, then preparing a whole range of tools and equipment. Apart from the convenience to artists, a major advantage of this arrangement was that the colourmen were able to test their materials thoroughly, providing consistent products with a degree of quality control. They were also able to assess new materials; pigments from recently discovered elements, or dyes and synthetic media from the burgeoning organic chemical industry.

Today if an artist is able to appreciate fully the new materials available from the colourmen, this creates all sorts of possibilities. But other artists may feel they have become divorced from their materials; they are no longer capable of judging for themselves; they have become dependent on products sold like toothpaste in tubes. If this is so, an understanding of the early development of painting techniques can be of more than historical interest; it can provide a positive way of advancing the art of painting.

There has been a renewed interest in painting practice during recent years, particularly from those artists who are struggling to master new techniques and come to terms with different materials. Because of this some constructive criticism has been made of the techniques discussed, in order to appreciate their potential and limitations. Not surprisingly there is a bias in favour of techniques of proven permanence and of materials of special stability, but it is hoped that a fairly balanced approach to the subject has been presented.

A number of books have been recommended for further reading both on the history of artists' materials and on basic painting techniques.

GLOSSARY

ACRYLIC Modern synthetic paint medium dispersed either in gel form (which can be thinned by white spirit) or in emulsion form (thinned by water), producing a flexible, soft film on drying.

ANODISED ALUMINIUM Aluminium which has been given a thicker protective oxide coating by an electrolytic process.

BEESWAX Natural wax produced by bees, refined and occasionally used to modify paint, usually with disastrous results. It blocks the 'drying' process in oil and is liable to separate out.

BISCUIT An unglazed, fired ceramic earthenware or stoneware.

BODY Common term for the degree of viscosity of a paint or varnish.

BODY COLOUR Thickly applied opaque colour effect typical of gouache as opposed to watercolour transparent washes.

BRUSHES Can be made from a variety of animals' hair e.g. hog's hair, camel hair (from the tails of squirrels!), sable etc. in a variety of shapes, quality and sizes. The term *pencil* was used until the nineteenth century to describe small pointed sable or camel hair brushes.

CANVAS SEPARATORS (Canvas Pins) Corks with double ended pins through their centres inserted at each corner of wet paintings placed face to face. Allows the artist to transport the paintings without damaging their surfaces.

CANVAS PLIERS Upholstery pliers with a wide grip also used for stretching canvas.

CHIAROSCURO The use of gradations of light and dark to describe forms in drawing and painting.

COALESCE Separate particles in an emulsion come together to form clusters or a continuous film.

COLLAGE Paper, fabric or other material glued onto a painting or support to create images, forms and interesting surface textures. When the composition created is dominantly three dimensional it is called ASSEMBLAGE.

COLOURMEN Suppliers of painting materials to artists.

COLOURMAN'S STAMP Colourman's trade mark on the reverse of a canvas or stretcher usually applied as a stencil, stamp or label. Changes in the form of the stamp can help in dating the canvas.

COMPLEMENTARY COLOURS For pigments e.g. red and green, orange and blue. Two colours in extreme hue contrast to one another which when mixed as pigments combine to form a grey. The complementary of a primary colour is a mixture of the other two primary colours e.g. the complementary of red is yellow + blue = green. (A saturated hue if stared at will leave its image in complementary colour on the retina.)

CONTAINERS FOR PAINT Artist's ready made oil paints were first kept in spherical bladders made from pig membrane tied at the top with twine (from the seventeenth century). Collapsible

lead and tin tubes were used from 1840 and in recent times have been replaced with aluminium alloy or plastic ones. A variety of jars and tins have also been used.

EMULSION A colloidal suspension of one liquid in another with which it is immiscible e.g. milk, acrylic paint, egg tempera.

EMULSIFYING AGENT An additive used to stabilise an emulsion.

ENAMEL 1. A paint made from oil, resin and finely ground pigment. It is usually glossy and rich in medium.
2. A vitreous ceramic glaze applied to pottery or metal.

EPOXY, POLYESTER RESIN Synthetic resins used to produce strong cold-cured adhesives which set by chemical reaction (conversion) and not through loss of solvent and coalescence.

FLUX A substance added to a solid to increase its fusibility.

FRITS Particles made by grinding previously fused flux, silica and colouring matter.

GLASS FIBRE REINFORCED RESIN Composite material made from felted or woven glass fibre embedded in a cold-cured polyester or epoxy resin. It can be easily moulded and is used for boat hull and vehicle bodies.

GLAZE 1. To cover lighter underpainting with a layer consisting of transparent pigments and excess medium. Traditionally used to add colour to forms modelled in monochrome opaque paint.
2. To impart a glass-like surface (such as enamel on a ceramic).

GLOST FIRING Fusing of a glaze by firing in a kiln.

GROUND A layer of opaque paint applied to a support to provide a suitable colour and surface on which to draw or paint.

GESSO A lean layer of size and chalk to form a ground on which to paint:
(i) originally in Italy slaked plaster of Paris + parchment glue;
(ii) in Northern Europe and more recently commonly chalk (whiting) + animal glue size;
(iii) acrylic gesso ground with acrylic resin binder.

GUM ARABIC The gum produced by the acacia tree, it is one of the gums used as a binder for painting in watercolour.

HARDBOARD Board made by drying felted wood fibres under heat and pressure. Sometimes it is tempered with oil or other adhesives.

HATCHING Shading or modelling with fine, closely laid parallel lines.

HONEYCOMB ALUMINIUM SANDWICH Two sheets of aluminium sandwiching a transverse honeycomb made from aluminium foil. The box-like construction is load-bearing only in the aluminium skins, hence it is very strong for its weight.

HUE A specific colour sensation such as red, yellow, blue etc. Hue depends on the wavelength of the observed light.

HUMECTANT Hygroscopic (moisture attracting) material such as honey or glycerine added to watercolour and adhesives to maintain a higher moisture content and retain flexibility and rapid resolubility of watercolour cakes.

INFRA-RED RADIATION Wavelengths of light just outside the red end of the visible spectrum

which can be detected by special photographic films.

LAKE A coloured natural or synthetic dye adsorbed onto a semitransparent base and used as a pigment.

LINE, RELINE, MAROUFLAGE, LOOSE LINE To attach an auxiliary support material to a canvas which is inherently weak or has deteriorated. This is usually achieved with an animal glue or wax adhesive and a stretched canvas support. Although in the case of *marouflage* a rigid support is used, and in *looselining* no adhesive is involved.

LINSEED OIL The most popular drying oil used as paint medium. This medium hardens over several weeks as components of the oil polymerise to form an insoluble matrix (linoxyn). Driers can be added to accelerate this process. Also *stand oil,* a partially polymerised (bodied) linseed oil is more viscous and less yellowing.

LITHOGRAPHIC CRAYON An oily crayon used to draw on a lithographic stone. In lithography the ink which is applied after processing sticks only to the areas that have been drawn on with this crayon.

MAQUETTE In sculpture, a small model or preliminary design for the main work.

MASKING TAPE Pressure sensitive tape applied to a surface to mask an area. It is used to produce a straight hard edge when the paint is applied. The tape is removed when the paint is dry.

MASTIC, DAMMAR Soft natural resins initially soluble in white spirit or turpentine. These varnishes yellow and embrittle on ageing and must be removed.

MEDIUM The component of paint in which the pigment is dispersed. When fluid, it is the vehicle which defines the handling properties of the paint. Following application it consolidates to form a binder enabling the pigment to adhere to the substrate. It also influences the optical properties of the paint film.
Linseed oil, gum, tempera and acrylic emulsion are examples of media.

MEGILP/MEGUILP/MAGILP Painting medium made by mixing mastic varnish with linseed oil and driers. Used to give the painting body. On ageing it becomes brittle and yellow.

MICROCHEMICAL TEST Very small samples viewed under a microscope are identified by their reaction to known chemicals solutions.

MOISTURE SENSITIVITY Hygroscopic materials which contain water such as linen, wood and paper absorb moisture and increase in volume as the relative humidity of the air increases.

PAPER
HOT PRESSED (H.P.) Indicates that the surface of the paper has been flattened or glazed by rolling or pressing.
NOT The trade abbreviation for 'Not Hot Pressed' and means that the surface of the paper is medium or matt.
ROUGH A comparative term for an unpressed surface and often means that the paper has been given an artificial texture.
TUB SIZING Carried out during the manufacture of paper and involves sizing paper after it has dried, by soaking it in a hot solution of gelatine or glue.
LAID PAPER This has a characteristic 'ribbed' appearance in transmitted light and is caused by the paper being thinner where it is laid over the

wires of the paper-making mould. This texture can be artificially pressed onto a wove paper on modern paper-making machines.

WOVE PAPER Has a woven or even appearance in transmitted light. First made about 1755, most modern papers are wove.

DECAL EDGE The feathery edge found round a sheet of hand-made paper. It can be produced artificially on some modern paper-making machines.

CARTRIDGE PAPER Originally used for wrapping gun cartridges, it is usually a hard, rough-surfaced, frequently tub-sized paper, often used for drawing.

KRAFT PAPER A very strong paper, usually a light brown colour, which was originally made from ropes but is now produced from un-bleached sulphate wood pulp.

PASTEL Pigments mixed with a minimum of binder (usually gum) and formed into sticks. They have a characteristic matt, granular appearance. They are applied directly to paper and have poor adhesion.

PIGMENT Small granular particles which are ground with the medium to impart colour to the resulting paint.

PLYWOOD Wood board consisting of a number of thin layers of rotary cut veneers glued together so that the grain of each layer is at right angles to the grain of the adjacent layer.

POLARISING MICROSCOPE An instrument used to identify small particles by observing their characteristic refraction of transmitted polarised light.

POLYMER A large molecule with a structure consisting of many identical units linked together chemically.

POPPYSEED, WALNUT AND SAFFLOWER OIL Alternatives to linseed particularly for whites. They are less yellowing but slower to polymerise and require lead white or another drier.

PRIMING The application of sizes and/or grounds to a support to prepare the surface for painting, modifying its absorbency, texture and colour.

RAKING LIGHT Illuminating an object from an oblique angle to emphasize its surface irregularities.

RESIN Transparent solid secreted by trees. When dissolved in organic solvents it is suitable as a varnish e.g. mastic, dammar. Also used more widely to describe any synthetic plastic material.

ROSIN The residue from the distillation of turpentine.

SATURATION The proportion of hue in a colour. For example, a clear sky is more saturated with blue than a hazy sky.

SCUMBLE Very thin layer of opaque or semi-opaque paint which partially hides the underlayer.

STAIN Applying paint to an absorbent surface in such a way that it is entirely absorbed.

STIPPLING Application of paint by dabbing with the end of a stiff brush held at right angles to the surface.

SHELLAC Natural resin soluble in methylated spirits (alcohol). Should not be used as a varnish on paintings but can be used to achieve a glossy hard surface for instance in French polishing.

SINKING The absorption of paint medium by a lean underlayer to produce a matt or dead surface.

SIZE An adhesive diluted in water. Usually means an animal glue consisting of collagen and gelatin. Rabbit skin glue, parchment glue, edible jelly are all forms of gelatin.

SQUARING UP A method of transferring a drawing to another surface on a different scale. A grid of vertical and horizontal lines is drawn on both surfaces and each square is copied freehand onto the new surface.

STACK (DUTCH) PROCESS A process for manufacturing white lead by exposing lead strips to acetic acid vapour and fermenting tan bark (or manure) in an enclosed building for three months.

STRETCHER A rigid wooden frame on which a canvas is usually stretched. The stretcher can be expanded by tapping in keys (wedges) inserted at the corners.

BLIND STRETCHER One which has panels inserted between the members (as in a traditional panelled door).

STRAINER A stretcher frame with fixed corners; it cannot be expanded.

TACKING EDGE The outside edges of a stretched canvas through which tacks are inserted attaching it onto the stretcher.

TEMPERA To *temper* means to add a binder or medium to a pigment. A *distemper* is a lean paint usually with glue size as the medium. *Tempera* usually refers to egg (either whole, yolk or white) used as the medium but can also refer to glue size.

TURPENTINE (SPIRITS) The traditional solvent or thinner for a drying oil (such as linseed oil) distilled from the resin exuded by certain trees e.g. the European larch, white fir and American longleaf pine.

WHITE SPIRIT, TURPENTINE SUBSTITUTE, NAPHTHA, THINNERS Solvents distilled from petroleum. They are colourless hydrocarbons boiling range 100-160°C used as a paint thinner.

ULTRAVIOLET FLUORESCENCE Visible light emitted from an object when irradiated by invisible ultraviolet radiation.

UNDERDRAWING Preliminary drawing subsequently covered by painting.

VARNISH An applied surface film, usually of a transparent, colourless resin. It imparts an even gloss to the surface wetting the paint and providing protection for it.

X-RADIOGRAPH Image produced on a photographic film by x-rays transmitted through an object.

THE TECHNIQUES USED IN
THE EXAMINATION OF PAINTINGS

There are many techniques available for gleaning specific information about a painting's construction. But the first and most comprehensive is that of direct observation. Fruitful observation requires careful and concentrated examination, supported by experience and knowledge. The brain tends to interpret the plethora of visual information in a pre-determined way which may lead to vital clues being overlooked. For instance, in a portrait, the face commands more attention than the background although it may only cover a small area of the painting. The background can often be more useful than the face in providing evidence of the construction of the painting. Occasionally underdrawing and initial paint can be seen below thinly applied background colours, and small areas of priming may be left exposed. An example is Thomas Gainsborough's portrait of 'Sir Benjamin Truman' in which the colour of the top left cloud is that of the barely covered ground. Its colour is pink, the tint which Gainsborough almost invariably chose to paint onto, its warmth permeating much of his work. Similar observations can reveal much about the creation of a painting, and the understanding of a painting's construction can add much to the pleasure of looking at it.

More information can be obtained by examining the parts of the object not usually on view. 'Tacking edges', through which tacks or staples were applied to attach the canvas to its stretcher, are often useful. If these are unprimed, then the canvas was prepared on the stretcher, usually by the artist. In addition artist's suppliers, often referred to as colourmen, sometimes stamp the back of their canvases. The stamp can provide useful information concerning the date and type of preparation of the canvas. The past history of the painting through the salerooms and exhibitions can sometimes be traced by the labels attached at such occasions, to the back of the frame, stretcher and painting.

A colourman's canvas stamp (Winsor & Newton)

Even after the most careful scrutiny, though, further information can be gained by the employment of a variety of techniques. One of these is a simple method for emphasising the relief of the painting. This is done by lighting the painting very obliquely from one side only. A photograph is then taken. The result can be quite surprising (see

David Hockney's 'A Bigger Splash' page 112, taken in these conditions). In the raking light photograph of Gainsborough's 'Pomeranian Bitch and Puppy' the brushmarking on the large dog shows clearly. Generally the manipulation of the paint in its surface effect is lost in any reproduction. These qualities are as important to a painting's appearance as any other property and are carefully considered by most artists. Gainsborough shows this concern in a letter to Robert Edgar:[1]

'You please me much by saying that no fault is found in your pictures than the roughness of the surface, for that part being of use in giving force to the effect at a proper distance . . .'

In raking light photographs, interesting alterations by the artist can be made evident (see Picasso's 'Three Dancers' page 85). Also ageing defects are enhanced. In the 'Pomeranian Bitch and Puppy' raking light photograph, a distortion across the middle of the painting can be seen. This has been caused by the horizontal cross-member of the stretcher. In addition the paint adjacent to some of the cracks is visibly raised. The photograph serves as a useful record as, in time to come, a comparison with it will show any worsening of these distortions.

All the observations made so far have been with visible light. By using invisible forms of radiation, otherwise hidden information can be extracted.

One form is ultra-violet radiation which has an interesting effect on many materials traditionally used to construct paintings; it causes them to fluoresce. That is they absorb invisible U.V. rays and re-emit visible light. This light is often characteristically coloured. Examples are zinc white, which fluoresces an acid yellow colour, and aged resins which frequently fluoresce a strong pea green. The technique is mainly of use to restorers as retouchings commonly appear dark. By this, old tears and other repaired damages become obvious.

The U.V. photograph of 'Pomeranian Bitch and Puppy' was taken after the removal of its varnish.

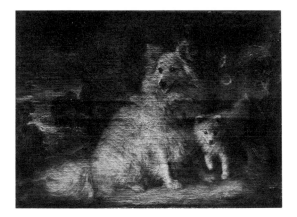

A raking light photograph showing the distortion caused by the horizontal cross-member

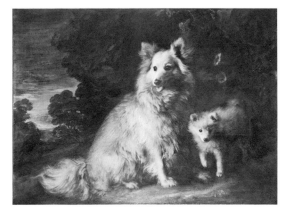

A photograph showing ultra-violet fluorescence of the painting

An area can be seen to fluoresce above the puppy and also to the left of the lowest convolvulus flower. The material fluorescing is the remains of an aged resin varnish and is very resistant to solvents.

A detail of the background foliage taken in ordinary light (see also page 24)

A technique of greater promise than fulfilment is infra-red reflectography. This relies on the fact that paint films are slightly more transparent to infra-red radiation than they are to visible light. Most opaque paint films owe their opacity to the difference in refractive index[2] between the pigment and the medium. The larger the difference in refractive indices, the more opaque the film will be. So, if this difference can be reduced, the film will be more transparent. Refractive index of a material does vary with the wavelength of light. In the infra-red part of the spectrum, the index of the medium and the pigment are often closer together than in visible light. This is related to a second important factor: that many pigments do not absorb in the relevant part of the I.R. This causes the paint film to appear more transparent in I.R. reflectography. Sometimes charcoal or graphite underdrawing on light grounds become visible.

As our eyes are insensitive to infra red radiation, a camera with a special film has to be used together with a filter to exclude visible light. Other more effective equipment has been devised (see the *National Gallery Technical Bulletin,* Vol. 2 1978 p. 7).

An infra-red photograph was taken of 'Pomeranian Bitch and Puppy' which revealed nothing of particular interest.

An increased transparency of the paint film viewed with visible light can occur over a long period of time. This causes what are known as 'pentimenti'[3], underlayers, once obscured by paint, that become visible. In this instance the refractive index of the medium increases with age and so moves closer to the pigments index. Again a more transparent paint film results which allows lower layers to be seen.

X-radiography is a technique known to many though not usually associated with the examination of paintings. Frequently the x-radiograph of a painting appears simple to interpret. So with 'Pomeranian Bitch and Puppy' the x-radiograph shows a reasonably clear image of the two dogs. To understand why, consider the image of a tack securing the canvas to the stretcher. This appears as white. The x-rays have been absorbed by the dense metal of the tack. Film is laid directly onto the painting. With the tack between the film and the x-ray source, the area of film corresponding to the tack is unexposed. In a conventional photograph this will correspond with dark areas in the

Thomas Gainsborough,
'Pomeranian Bitch and Puppy'
c.1777 detail of the sky
and landscape

image focused onto the film. When the x-radiograph plates are developed, the tack appears as white as do dark parts of the subject on the negative of a conventional film.

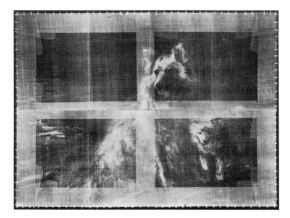

The x-radiograph of 'Pomeranian Bitch and Puppy'

Throughout the history of oil painting lead white has been used, almost exclusively, until recent times. Due to the dense mass of the lead atom, lead compounds are more opaque to x-rays compared to other pigments. As with the tack, a thick layer of lead white will totally absorb x-rays. The whites in the painting correspond with the unexposed and, therefore, white areas on the film. A second factor is the thickness of the paint layer. By varying the exposure time and the energy of the x-rays, only the thickest brush strokes of pure white need totally absorb the x-rays. Mixtures with other colours and thinner layers will then increasingly transmit the radiation causing the film to be exposed. When developed, gradations from light to dark will result. So although x-radiographs can be similar to the painted image, care has to be taken in their interpretation.

The x-radiograph of 'Pomeranian Bitch and Puppy' provides a useful illustration. On close examination the canvas weave can be detected. This appears as a negative image of a piece of canvas, e.g. the threads are dark and the gaps between them are light. In fact it is the priming's extra thickness where it fills the canvas texture that causes the gaps between the threads to appear light. If a chalk gesso layer had been applied the canvas would have remained invisible on the x-radiograph. As it is there can be no doubt, in view of Gainsborough's thin paint film, that the ground contains lead white.

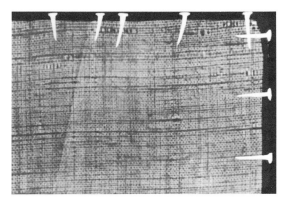

A detail from the x-radiograph showing the canvas texture and tacks securing the canvas to the stretcher

This is not a full description of x-radiography applied to paintings. For instance, thick layers of other pigments and areas containing one of the few other x-ray opaque pigments such as vermilion, will appear light on the x-radiograph. However a knowledge of the general principles of x-radiography is enough to make an intelligent assessment of an x-radiograph possible.

The most dramatic images revealed in an x-radiograph are obscured paint layers in which the distri-

bution of lead white is meaningfully different from that in the surface paint. This occurs, for instance, if an abandoned canvas has been re-used by an artist and the first image has been painted out. Of more interest to a study of the artist's method are the changes of design that have been made during the painting process. Picasso's 'Three Dancers', see page 82, is a fine example.

In all the examination techniques described so far, the painting has been left intact. If it is possible to take small samples of paint, several further forms of analysis can be performed.

One relatively straightforward procedure consists of removing a small fragment of paint with a scalpel. This is carried out under a microscope. The sampling is usually done adjacent to already present damage where it will be least noticed. All paint layers should be included in the sample. The paint fragment is mounted in a block of clear resin which is ground away to reveal the sample edge on. A cross-sectional view of the sampled paint is obtained.

With a good sample, observations about the number of paint layers, their colour and thickness are easy to make. The procedure requires careful selection of the area to be sampled. Damages are the most likely places to find re-touching which may be confused with original paint. Also the structure of the painting may not be truly represented by the severely limited number of samples that it is possible to take.

The samples from 'Pomeranian Bitch and Puppy' were taken where the tacking edges have been cut off. The present edges of the painting are covered by brown paper and the frame rebate, so are not normally on view. Most obviously the cross-sections show how thin Gainsborough's paint films are.

It is possible to cut extremely thin slices from

A cross-sectional view of the paint film

viewed at x 312.5

Total thickness of sample 190μm

Thickness of paint films approx. 25μm

�	transparent dark green glaze layer
	semi opaque light green layer
	two opaque layers of indeterminate colour
	transparent light yellow pigment particles
	red pigment particles
	very dark layer
	ground layer
	white particles

N.B.: 1,000μm = 1 millimetre

the mounted cross-section. This allows some analysis to be carried out using a transmitted light polarising microscope. At high magnifications many pigments can be recognised by their characteristic shape, refractive index, or other optical properties. More commonly, for this form of analysis small samples are taken from across the

painting's surface. By sampling under a low powered microscope, the minute amount of paint required for this form of analysis can be taken and the sampled area be visually impossible to detect with the unaided eye. Micro-chemical testing can sometimes be performed to confirm the initial analysis. A combination of these two techniques showed that the blue used in the sky of 'Pomeranian Bitch and Puppy' was Prussian blue.

Through the various means described a full idea of both the artist's method and materials used in a particular painting, can be built up.

[1] Mary Woodall, Editor, *The letters of Thomas Gainsborough,* 2nd Ed. revised 1963, No.43 p.91

[2] Refractive index is a ratio derived from the degrees of refraction, or bending, of light as it crosses a boundary between two materials. The greater the difference in refractive index between the two materials, the more the light is refracted. Additionally, part of the light is reflected at the boundary and does not enter the second material. This reflected component will be larger if the refractive index difference is greater.

[3] Pentimenti are also attributed to basic lead carbonate saponifying drying oil to form lead linoleate. Incidentally, due to this chemical reaction, lead white forms unusually tough and durable paint films.

THOMAS GAINSBOROUGH 1727-1788

'Pomeranian Bitch and Puppy' 1777

Oil on Canvas, 83.1 × 112 (32¾ × 44)

Gainsborough's method of constructing a painting was straightforward. It is not known whether or not he prepared his own materials. Certainly suppliers of ready ground oil paint were well established in London even at the start of his career. A writer on painting commented in *c.*1710:

> 'Note that [colours] are all to be bought ready ground at the colour shops in London, tied up in bits of bladders and of about the bigness of walnuts; and are done much finer and cleaner (and almost as cheap) than anyone can possibly do them himself. All painters generally have them thus'.[1]

The earliest named colourman's business known is recorded in 'The London Tradesman'[2] when Robert Keating, of the White Hart, Long Acre is said to have, in 1749, 'furnished [a painter] with every article he uses . . . ' This indicates that by 1777, when 'Pomeranian Bitch and Puppy' was executed, anything from a primed canvas to ready ground paint would have been available.

In common with many other painters of his time, Gainsborough painted on linen canvas stretched onto a wooden strainer and primed with a tinted ground. He invariably chose a dull pink colour, such as can be seen in the unfinished painting 'The Housemaid'. Here, the pink ground shows through and by using this as the basis for the flesh colour, the artist has modelled the face with a minimum of light and dark scumbles. Whether or not the canvas was prepared commer-cially or by Gainsborough, the same materials would have been used. One or two coats of animal glue, usually made from rabbits' skins, would be applied to the stretched linen. After allowing this 'sizing' to dry, a coat of lead primer, with added pigments, would be brushed or trowelled on.

Primer contains a larger proportion of pigment and filler to medium than does artists' paint. This results in the ground being lean in medium. Richer paint should then be applied on top. To paint fat (rich in medium) over lean is the golden rule of oil painting.

There are two important physical properties of grounds which determine the strength of the bond between ground and paint layers, their absorbency and texture. If a little medium soaks out of the applied paint into the ground, better adhesion results. Also a rough surface helps the paint grip the ground. In 'Pomeranian Bitch and Puppy', large coarse lumps in the ground can be seen in the thinly painted areas.

Once the ground was dry, painting could commence. From looking at his unfinished works it appears that Gainsborough swiftly drew in the main design. Few preparatory drawings for the paintings of his later career exist so almost certainly he perfected the architecture of the composition, at this initial stage, on the canvas. The paint used was very liquid but must have contained added medium as well as turpentine. Paint was usually ground with just enough medium to coat each

pigment particle and is then referred to as being fully bound. When thinned, the medium would be more readily sucked out by the absorbent ground. If only turpentine were added, underbound pigment would be left on the surface. Adding more medium would not only compensate for this loss, but cause the paint to remain wet for longer, allowing alterations to be made by wiping off unwanted parts.

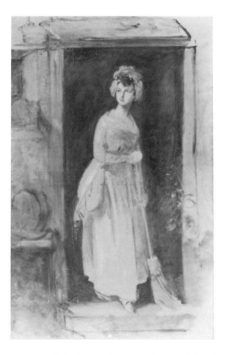

Thomas Gainsborough, 'The Housemaid' *c.*1782-6

This process can be clearly seen in 'The Housemaid'. At the top right corner there are a couple of dark lines that have the crispness of first strokes of paint. In nearly every other area paint has been applied, thinned down, re-applied and generally worked over. An area where this shows well is just below centre on the left side, as viewed, where some sort of washing tub has been loosely drawn. Great sweeps with a paint-free brush (possibly dipped in turpentine) have been made across the initial dark paint to reduce its strength. Subsequently light coloured paint has been applied depicting the object in a changed position. This light coloured paint has been used in several other areas to locate sundry items such as a hen sitting on the doorstep. It is an example of poorly bound paint, as can be detected by its matt surface. The paint has retained this by absorbing the recently applied varnish. Had Gainsborough generally mixed pure turpentine to thin his paint, this effect would have occurred more widely in the painting.

Gainsborough's concern for correctly proportioning the composition at an early stage was due, in part, to the almost watercolour-like use he made of oil paint. Fundamental changes in the composition would be impossible to hide beneath the thin paint films he used.

As the design was resolved, paint was added to reinforce the image. Through many overlaid brushstrokes a sumptuous effect was increasingly built up. Often washes of colour have a few details brushed onto them; a fast and efficient painting technique. In 'Pomeranian Bitch and Puppy' this can be seen particularly well in the background to the top right of the dogs. Here Gainsborough's free-flowing brush mark is most evident, especially in the depiction of the convolvulus plant.

Fluid paint must also have been used to achieve these effects. Gainsborough's daughter, Margaret, observed that – 'his colours were very liquid and if he did not hold the palette right would run over'[3]. As already discussed, this was not achieved by adding only turpentine. Holman Hunt in his famous lectures to the Royal Society of Arts in 1880 states that Gainsborough's vehicle

was 'evidently made with a large proportion of mastic varnish'.

With regard to pigments, Gainsborough is known to have exercised the greatest care in his choice. Some samples analysed from 'Pomeranian Bitch and Puppy'[4] contained, as might be expected, earth pigments, lead white, yellow lake and Prussian blue. The latter was discovered in 1710[5] and is regarded as the first of the modern colours to be introduced.

Bitumen, a pigment commonly used in the eighteenth and nineteenth centuries, was applied on top of the paint depicting the convolvulus plant. Several blobs of it can be seen to have wrinkled on the surface and disconcerting ridges have formed. Generally this colour never dries and subsequent paint can freely contract on top of it, resulting in cracks forming which are sometimes several inches wide. By applying it last in this painting, Gainsborough contrived to use this often disastrous colour in the safest way possible; an illustration of the supreme mastery he had of his materials.

It is difficult to know for certain if Gainsborough varnished his finished paintings. The paint would have to dry for a long period before a general varnish could be safely applied. Several references to varnish are made by him in his letters. He wrote to Mr Thomas Harvey, '. . . if you should find anything of a chill come upon the varnish of my Pictures, owing to its being a spirit of wine Varnish, take a rag . . .'[6], and also, in a surviving fragment of a letter he says, 'I have sent you two bottles of Varnish of my own making.'[7] The final stage of the secret process for making his varnished drawings was to apply three coats of mastic varnish, as described to W. Jackson[8]. These remarks are particularly interesting as few known references were made to the question of varnish by 18th-century artists. There are traces of a very old varnish on 'Pomeranian Bitch and Puppy' and possibly these are the remains of a Mastic varnish Gainsborough applied.

Although Gainsborough's method was traditional and straightforward, he had quite an individual way of using it. This developed through his remarkable facility for using paint. Typically, the paint is thin, with carefully manipulated degrees of transparency and opacity, with the light tone of the ground often developing a richness of colour not obtainable by adding white to the paint. By such means and the use of a strongly drawn, very evident brushmark, an unusually lively effect is produced.

To our great benefit, thin paint films are the most stable. The fact that his paintings have survived so well is, indeed, final confirmation of the sureness of Gainsborough's choice craft.

[1] Anon William Whitley, *Artists and their Friends in England 1700-1799,* 2 Vols London and Boston 1928 Vol.I p.331
[2] Ibid., pp.331-2
[3] Walter Thornbury, *The Life of J.M.W. Turner R.A.,* 2 Vols London, 1862 p.62
[4] Analysed at the Tate Gallery using polarised transmitted light microscopy and micro-chemical testing.
[5] Rosamund Harley, *Artists' Pigments 1600-1835,* Butterworths, London 1970 p.65
[6] Mary Woodall, Editor, *The Letters of Thomas Gainsborough* London, 2nd Ed. revised 1963, No.43 p.91
[7] Ibid., No.100 p.173
[8] Ibid., No.103 p.177

GEORGE STUBBS 1724-1806 'Horse attacked by a Lion' 1769
An Experiment with Permanence

Enamel on Copper 24.1 × 28.2 (9½ × 11⅛)

That permanence is desirable in a painting has always been an unspoken assumption between artists and their patrons. During the Renaissance, when a donor commissioned an altar piece to reside in a church, it would be expected that the work would remain as a permanent part of the fabric of the building. At a later date, portrait painters were employed to record for posterity the appearance and interests of their sitter. As the role of the artist in society became less clearly defined, it remained in the artist's interest to express his perception of the world in a form which would survive for as long as possible.

Stubbs was born in Liverpool in 1724 and made his name painting animals and sporting subjects in oil[1]. This was a field which was readily appreciated by most of the wealthy landowners who could afford to buy oil paintings. Stubbs's contribution was in his study of anatomy by means of which he was able to depict precisely both the general and the specific features of each horse.

For reasons which are not quite clear, from about 1769 onwards, Stubbs embarked on his experiments with enamel painting. It may have been because he considered his current reputation would be ephemeral, or possibly because he had noted some deterioration of his earlier works, or perhaps because he was driven by the same spirit of scientific enquiry that had led to his dissections and anatomical drawings. Whatever the reasons, he undertook to create works that would maintain their pristine condition almost indefinitely and to do this he eventually enlisted the help of Josiah Wedgwood and his company.

The achievement of permanence not only requires the use of very stable materials, but also an understanding of the limitations of these materials. Artists such as Gainsborough produced successful results by thoroughly comprehending all facets of the oil medium and hence restricting the demands which they put on the material. Stubbs had to learn all about enamelling, and not merely adapt his painting technique. The only other well-known painter using enamel at this time was Richard Cosway who was painting 'loose and amorous subjects from abroad'[2]. Otherwise enamels were chiefly employed for miniatures or 'toys'.

For his first attempts, Stubbs chose a support of copper, a metal known to be immune to rapid corrosion and readily available in small panels about twelve inches square. It was possible to obtain larger sheets but they were thicker, heavier and more expensive. In fact copper was a well-respected support material for small paintings in oil, which was usually applied directly employing the copper as the ground colour. It was the most stable material available, being superior to wooden panels which expand and contract or warp with changes in relative humidity. So Stubbs had begun his new technique on a sound basis.

His next step was to apply a layer of white

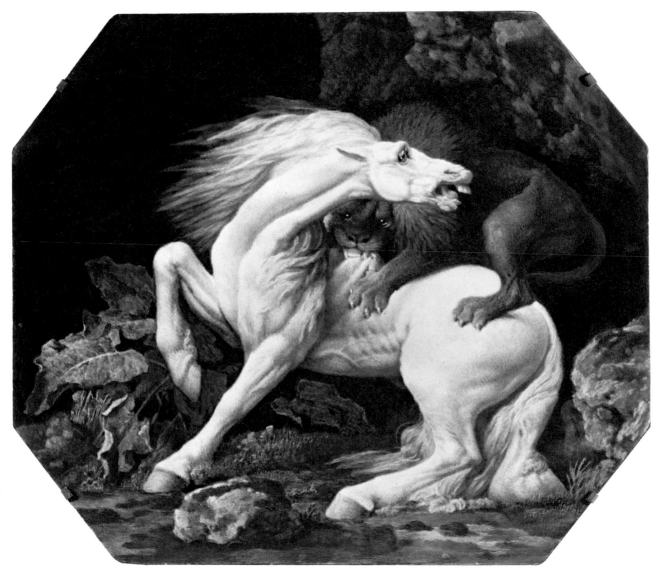

George Stubbs,
'Horse attacked by a Lion'
1769

ground to the copper. It would have been wise to score the surface and clean it thoroughly to assist adhesion. Then he brushed on a layer of white metal oxide (almost certainly tin) mixed with silica and a flux of borax and lead. On analysis by the British Ceramics Research Association, the later portrait on ceramic of Erasmus Darwin from the Wedgwood Museum, Barlaston was found to contain alumina, silica and traces of calcium and potash[3]. There is no mention of lead, but its presence would seem to be likely for the works on copper in order to keep the firing temperature below 850°C.

The art of glazing was well established; Wedgwood had just developed his copper green glazes (1754-9) and the traditional techniques of glazing had been described in *Le tre Libri dell'Arte del Vasaio* by Cipriano Piccolpasso as long ago as the sixteenth century. Stubbs set about developing as many as nineteen different 'tints' which would not change colour on firing. There are very few metal oxides which can be used in glazes, but what seems more likely is that Stubbs prepared 'frits' by firing mixtures of ores with flux and then grinding the coloured glaze produced. The flux would presumably be chosen to melt at a slightly higher temperature than the enamel flux.

With these tints Stubbs could make up a paste by adding flux and either turpentine or gum, allowing him to paint onto the previously fired tin-oxide ground. It would have been like using lean oil paint or gouache, so Stubbs would have had little difficulty. The colour when wet would be similar to the finished glaze. If he made a mistake it could be wetted and washed off, but he would have to be careful lest fingerprints made parts of the surface greasy, in which case the glaze might be rejected in places. Many artists would not have been able to cope with this technique but Stubbs's meticulous oil technique was also quite demand-

ing. He made accurate squared up drawings on paper before beginning on his enamel painting. The paint was applied in thin scumbles and glazes making full use of the white ground. The result when fused in the kiln was an enamel glaze which would remain inert under nearly all conditions. The result at present can differ very little from when Stubbs first saw it returned from the kiln. Note that the horse is much whiter than any white possible in oil medium.

This sounds like an ideal way to achieve permanence, yet Stubbs was severely limited by a number of factors. Firstly he did not know exactly how the colours would turn out; this would depend on the firing temperature, the purity of the glazes and flux, and the thickness of application. Only the latter could be controlled by Stubbs – after a little experience. Stubbs was left at the mercy of the kiln operator, his packing of the kiln, distribution of the charcoal and control of the air flow. Should the temperature rise too high the glaze would flow and the colours merge, the frits would loose integrity and the hard edges of the composition would be destroyed. Too low a temperature would fail to form a glaze.

Given these limitations the results achieved can be readily appreciated. The horse has been painted with a draughtsmanship comparable to many of his works in oil, and although the treatment may appear to us dramatic, this is not a consequence of the medium. Considerable detail has been incorporated into the composition such as plants, the texture of the rocks, manes of both the horse and lion and of course the signature. A complete tonal range has been achieved from almost black to white. In addition the resulting surface was glossy and required no potentially discolouring varnish.

Stubbs further developed the technique by replacing the small copper plates with larger earth-

enware 'biscuits', which must have been more familiar to Wedgwood, allowing Stubbs to take full advantage of the potter's art. Although the rough absorbent texture may have been aesthetically more acceptable to Stubbs, size was still a limitation. Attempts to produce very large supports were only partially successful, frequently emerging cracked, but eventually oval biscuits up to 30″ × 40″ were made. The other drawback of biscuits is that they may break during glost firing sometimes leading to distortion in plane. Hence it would be impossible to repair any biscuits broken in the kiln.

Stubbs was however, despite some set-backs, relatively successful in developing the technique and was able to continue painting in his smooth precise style confident in the knowledge that his works would last. Stubbs certainly did not invent a new painting technique but he showed the great potential of enamelling. It is significant that no one in the field of fine art continued to develop this technique: clearly it was extremely dependent on a close relationship with Wedgwood. Few artists would have either the opportunity of such sponsorship or the determination to succeed in a completely different medium.

[1] Basil Taylor, *Stubbs*, Phaidon, London, 1971
[2] Ozias Humphry, *Memoir of Stubbs,* Picton Collection, Liverpool City Libraries, Unpublished MS.
[3] Bruce Tattersall, *Stubbs and Wedgwood,* London, 1974, Tate Gallery catalogue.

THOMAS GIRTIN 1775-1802

'Bamburgh Castle, Northumberland' *c*.1797-9

Watercolour, 55 × 45 (21⅝ × 17¾)

Landscapes have been painted in England in watercolours from the early seventeenth century. These early paintings sometimes attempted to portray the 'ideal' landscape, but more frequently they were topographical sketches, little more than correct views of abbeys, castles, ruins, etc..

Thomas Girtin, born in February 1775, received his first instruction in drawing from a Mr Fisher, a drawing master. He was also employed to colour engravings as an apprentice to John Raphael Smith, well known for mezzotints after Reynolds, Romney and Gainsborough. Here Girtin learned the skill of applying washes of paint in even and precise strokes. He also met Turner who was similarly employed. Later the two painters worked under the patronage of Dr Thomas Monro, practising watercolour technique, among other things copying drawings by J. R. Cozens. At this stage Girtin was influenced by artists such as Piranesi, Marco Ricci, Canaletto and Rubens, but his first interest was in making nature his model.

Following the topographical watercolour tradition, Girtin began to paint in the accepted method, by outlining the scene in pen and ink and then finishing the work by filling in the colours later in the studio according to the manner in which he had been taught. He was quicker to use a wider range of colours than some of his contemporaries and soon began to produce outstanding work.

The traditonal technique of colouring is very straightforward. Watercolour paint is composed of small particles of pigment which give the colour. The pigment is ground in water to a smooth consistency and mixed with medium to bind it. The binder for the pigment is gum arabic, which is derived from the acacia tree and is water soluble. Water is used to spread and dilute the colours. The amount added influences the density of colour in the transparent wash, which soaks into the paper and dries, forming an intimate bond with the paper.

The more opaque type of watercolour, called gouache, is produced by the addition of white pigment to the watercolour, such as lead white and later, zinc oxide. Gouache was used extensively through the centuries in illuminated manuscripts and in miniature paintings.

Traditionally the pigments in common use are derived from earth colours, vegetable, insect and root dyes, and a few rare minerals. Until the middle of the eighteenth century it was customary for artists to prepare their own colours by grinding, washing and mixing the pigments with gum. The raw materials were on sale at apothecary shops with all the other drugs available at the time. By contrast, prepared oil colours were sold by artists' colourmen from the 1650s onwards.

One of the first colourmen who prepared watercolours was Middleton, whose price list published in 1775 includes watercolours in cakes, camel hair brushes and also black lead pencils, all inexpen-

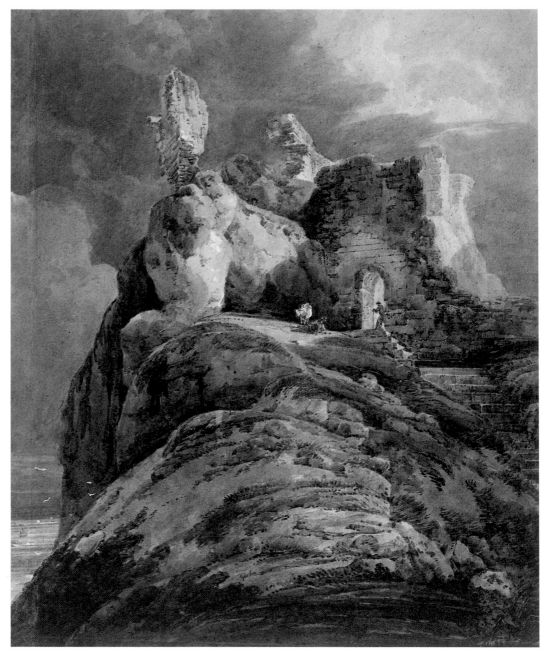

Thomas Girtin,
'Bamburgh Castle,
Northumberland'
c.1797-9

sively priced. The others, like Norman and Reeves, followed. Marketing 'watercolours in cakes' greatly improved the popularity of the medium. The addition of glycerine or honey to the gum arabic prevented the cakes drying out. They were shaped into rectangles, easily fitting into a box, to be carried around wherever needed. By 1800 specially manufactured mahogany boxes were in common use having evolved from the first ivory colour boxes, the size of a snuff box, first mentioned in 1732.

Unfortunately some of the pigments used by the artists of the day were not very permanent, and if exposed to light, they had a tendency to fade. This is the case with indigo in Girtin's paintings. During the eighteenth century a range of artificial pigments was produced of which Prussian blue was perhaps the most popular. When Girtin was touring the country in 1796 under the patronage of Mr James Moore, impressed by the scenery he started to paint his pictures on the spot, abandoning the idea of colouring the drawing later. Perhaps because of this, his watercolours have a freshness and boldness which capture the subtle effects of light and colour. Yet the quality of precision instilled by his training is retained.

In the following year he exhibited ten of his works. These were extremely well received, so from this time onwards he was his own master, translating impression from nature into his particular language. Previous influences were merged to create a style that was at first individual, but soon widely imitated.

His individuality was also reflected in his careful choice of paper. The paper was always hand-made, laid (machine-made paper was not yet available) and had a heavy texture. This means that the pattern left by the mould in which the paper is made is quite pronounced and visible through the design. It can be seen as a sequence of horizontal and vertical lines.

Girtin was the first artist to practise the custom of drawing and painting on cartridge paper. He did this in order to avoid the 'spotty glare' common in drawings made on pure white paper. Cartridge papers were not usually of the best quality since, as their name suggests, they were originally designed for the manufacture of rifle cartridges. Later they were used widely as wrapping paper. They were tough, rough surfaced, whitish-brown colour and full of impurities manifesting themselves on the surface of the paper as brown or black speckles. To increase their strength, cartridge papers were sized by saturating them with a hot solution of gelatine or animal glue to which alum had been added. This process is known as 'tub-sizing' and applies to hand-made papers as well as modern machine-made papers. The alum was to prevent the gelatine from becoming soluble in cold water. Cartridge papers can now be bleached to any degree of whiteness, they are named according to their use: hosiery cartridge for wrapping; ammunition cartridge; offset cartridge for printing; engineer's cartridge for drawing.

By the time Girtin painted the view of Bamburgh Castle he knew everything that was to be known about watercolours. He had already introduced one technical change, that is the substitution of a warm paper for a cold white one. The effect of white colour where needed was achieved by opposing this warm toned unpainted paper with cold blue washes.

Now, he restricted his palette to a very few colours which allowed him to express fully his emotions and depict the potency of light and darkness. In painting Bamburgh Castle, Girtin showed his preferences for choosing a cartridge paper support with a warm 'biscuit' colour. The

painting started as a very brief, impatient pencil drawing visible in the middle of the picture. The first layer of a lightly applied colour followed. The brush strokes appear to be perfectly spontaneous but the rich blots of colour are precisely placed. There follows a more detailed layer in darker, deeper tones of greens and blues applied with a smaller brush to emphasise the shadows and to sculpt the landscape. He also uses a few strokes of white opaque paint, not so much to bring out the highlights but more to portray details such as the seagulls and a cow. He leads us into the picture through a nearly empty foreground to the main part of the composition, the ruins of the castle, without fear of boring the spectators.

On the left side of the picture is a vertical line formed by overlapped layers of paint. This is not a crease or fault in the paper, it indicates that Girtin at first painted a much narrower composition but during execution of the painting he must have changed his mind and enlarged it by adding another 30mm of paint. The addition overlapped the already dry paint on the right side resulting in this line being much darker than the rest of the sky.

Throughout his short life (he died in 1802), as far as we know, Girtin made only two attempts to paint in oil, a view in Wales exhibited in 1801 and a panorama view of London exhibited in 1802 after his death. Girtin's skill helped to raise the status of watercolour painting to something approaching that of oil, to be regarded no longer as simply a means of illustration, but as a respectable medium for artistic expression.

SOURCES

Walter Koschatzky, *Watercolour History and Technique* translated from German by Mary Whittall, Thames and Hudson, London, 1970
Michael Clarke, *The Tempting Prospect – A Social History of English Watercolours*, British Museum, London, 1981
Arthur M. Hind, *A History of Engraving and Etching from 15th century to the year 1914*, Dover Publications Inc. New York

JOHN CONSTABLE 1776-1837

'Flatford Mill (Scene on a Navigable River)' 1816 – dated 1817

Oil on Canvas, 101.6 × 127 (40 × 50)

John Constable's working methods varied only a little through his career. For much of his life he drew and sketched out of doors in pencil, watercolour and oil, keeping these documents in his studio for future use. Of a group of oil sketches executed in Brighton in 1825 he wrote: 'They were done in the lid of my box, on my knees as usual . . . , I put them in a book on purpose as I find that dirt destroys them'. On the back of 'The Sea near Brighton' he noted: 'Brighton Sunday, Jany 1st: 1826. From 12 till 2 P.M. Fresh breeze from S.S.W.'. Such details interested him and his cloud studies of 1821-22 are similarly annotated. Some of his sketch books survive. He used very small ones (approximately 4¼'' × 3½'') for pencil drawings, larger ones for drawings and watercolours, and many of the oil studies are little larger than that. Later in his career he made full size oil sketches for his larger paintings.

'Flatford Mill' was started in 1816, and completed for the Royal Academy Exhibition of 1817. There are a number of surviving drawings which relate to it, and a record of an oil sketch which was probably the final preparatory document. An x-radiograph of 'Flatford Mill' shows the original composition which includes a second horse, linking the sketch and the painting more closely[1]. Although this alteration is visible in ordinary and raking light, it was not noticed until seen on the x-radiograph.

It was probably late summer when Constable started work on the final painting in his studio. As for so many of his paintings he used a fine to medium weight linen canvas with a simple weave, primed with a white ground. Analysis shows that the ground contains both lead white and chalk. Over this there is a thin wash of raw umber. A similar preparation can be seen on the unfinished 'Dedham Lock and Mill'. Another ground he favoured was a warm mushroom colour. Unusually, Constable has put this type of ground over the white and umber layer in 'Flatford Mill'. Under thinner paint layers the nature and colour of the ground can have a marked effect on the final appearance. The paint layers of 'Flatford Mill' are so thick that this is not the case, so Constable's reasons for changing his mind are a puzzle.

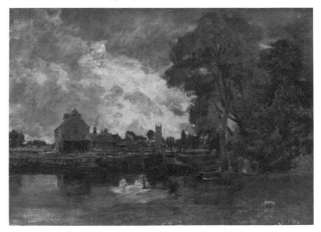

John Constable, 'Dedham Lock and Mill' *c*.1819

So thorough was Constable in the studies and sketches he made for a painting, that he did not use outline drawing on his canvas, but started painting the composition directly. His working methods at this time can be seen in 'Dedham Lock and Mill'; he seems to have been quite traditional in his technique. With flat dark colours he mapped out the composition in terms of tone and form before building up layers of colour, light upon dark. Sometimes he blended his colours on his palette, and allowed each layer to dry. He also painted wet in wet, blending or half blending the colours on the canvas. This is the technique he used to paint the reflections of the barges in the water in 'Flatford Mill'. Later in his career he was criticised for his use of white flecks, usually applied with a palette knife. In 'Flatford Mill' the beginnings of 'Constable's snow' can be seen in the white highlights applied lightly and sparingly with a brush. In later works this effect tended to dominate and even Constable became uneasy about it. Another more traditional device that he used was scattering colour-enhancing red through the painting, seen here in the distant cows, the men's hats and belts, the horse's browband and the red flowers growing by the stream.

Constable's interest in the use of colour, and his friendship with George Field[2], the artists' colourman, would ensure his trying new pigments as soon as they were available. But Constable died in 1837, before so many of the exciting discoveries of the later part of the century. Chrome yellow, introduced about 1820, is a new pigment he mentions and this and emerald green were found on a palette used later in his life. A recent analysis of pigments used on 'Flatford Mill' did not reveal the use of these two pigments[3]. The greens were found to be Prussian blue mixed with raw and burnt sienna, and yellow ochre. So Constable's famous fresh greens were made using pigments that had been available for about a hundred years. The blue pigment in the sky is all natural ultramarine. As a friend of George Field it would not have been difficult to obtain this pigment. Cheaper artificial ultramarine was not available until the 1830s and cobalt blue was first listed as an artists' pigment in 1816, making it very new at the time 'Flatford Mill' was painted. It would be interesting to know whether Constable ever used it for skies in preference to the lovely but costly ultramarine blue.

Constable's pigments have not often, if ever, been analysed before. It is therefore worthwhile noting the actual results:

Flatford Mill 1816/1817
Sky: natural ultramarine
Trees: Prussian blue, raw sienna, burnt sienna
Yellow sunlight in middle distance: yellow ochre
Boy's yellow jacket: yellow ochre
Use of lead white and vermilion indicated on
 x-radiograph.

Palette: Probably c.1835-7
Vermilion
Emerald green
Chrome yellow
Madder identified by characteristic fluorescence
 in U.V. wavelengths.

Trimmer[4] and Leslie[5] both refer to Constable's pigments and medium. Trimmer says 'He had his colours from Field, who was celebrated for his madders, which he used freely, as well as ultramarine. The madder and blue form a purple, and his clouds are purple instead of grey . . . in his early pictures he employed vermilion and light red.' 'He used the spatula freely, and the vehicle he employed enabled him to plaster. This was copal

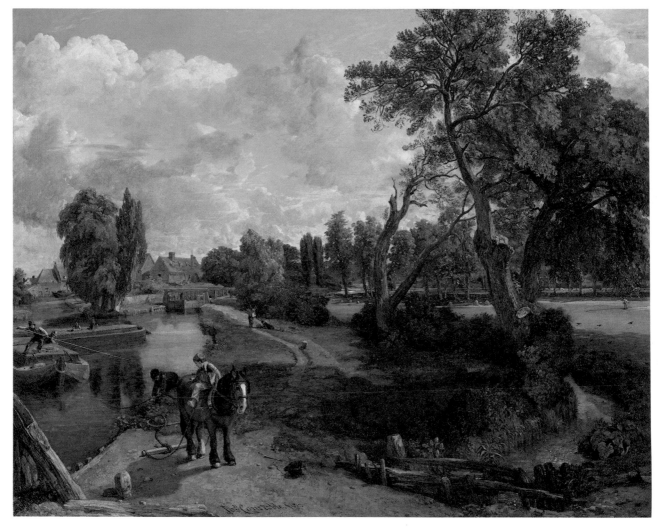

John Constable,
'Flatford Mill (Scene on a navigable river)'
1816

varnish and linseed oil diluted in turpentine'. Leslie says 'Though averse to all quackery in art, Constable's technical knowledge equalled, if it did not exceed, that of most men of his day . . . Later in life he was constantly in communication with Mr George Field, the principal maker of the finest class of artists' colours of which Constable always had a large store, in the form of powder, chiefly of the various shades of ochres, madders, ultramarine and the lovely greys known as ultramarine ash'. He goes on to describe Constable's method of preparing linseed oil. Samples of paint from 'Flatford Mill' and the palette were analysed for medium[6], and the results suggest that Constable was aware of the different properties of various drying oils. He probably used walnut oil or a mixture of poppyseed and linseed oils to bind the blue paint of the sky and the white of the clouds. Walnut and poppyseed yellow less than the better drying linseed oil which was used where such an alteration of colour was of less significance, as in the green leaves of the trees. There are indications that he may have used a pine resin in his paints, but this analysis ruled out the presence of copal varnish. We do not know what Constable used to varnish his paintings – probably mastic in turpentine. But they would be varnished and framed before hanging on exhibition.

In 1817 'Flatford Mill' was exhibited at the Royal Academy as 'Scene on a Navigable River' but not sold. On 17 October 1817, Constable made a large pencil drawing of the trees on the right[7]. Leslie Parris's observations concerning the reworking of parts of the trees are confirmed by microscopic examination of the painting, and a cross section taken from the top edge. The top half of the painting has a second layer of warm mushroom ground over the blue and white of the sky. The trees and sky have then been entirely repain-

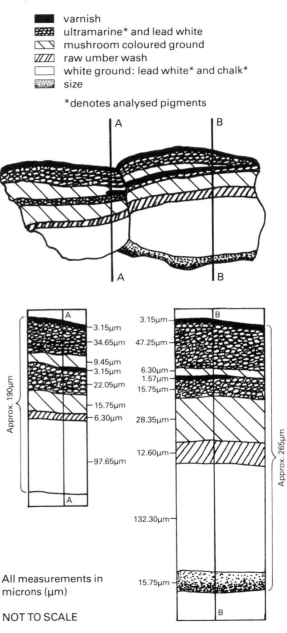

A cross-section through the paint film and grounds, a sample taken from the sky

■ varnish
▨ ultramarine* and lead white
◹ mushroom coloured ground
▨ raw umber wash
☐ white ground: lead white* and chalk*
▨ size

*denotes analysed pigments

A

3.15μm
34.65μm
9.45μm
3.15μm
22.05μm
15.75μm
6.30μm
97.65μm

Approx. 190μm

B

3.15μm
47.25μm
6.30μm
1.57μm
15.75μm
28.35μm
12.60μm
132.30μm
15.75μm

Approx. 265μm

All measurements in microns (μm)

NOT TO SCALE

ted. During this second painting minor alterations were made, many of which are visible in raking light, infra-red, photographs or as pentimenti. Unfortunately the x-radiograph does not show the original trees or sky, as lead white has been used in so many of the layers here. In 1818 the painting was exhibited at the British Institution, this time as 'Scene on the Banks of a River'. It still did not sell and had to be bought in even twenty years later in the artist's studio sale; Constable's daughter Isabel bequeathed it to the National Gallery in 1888.

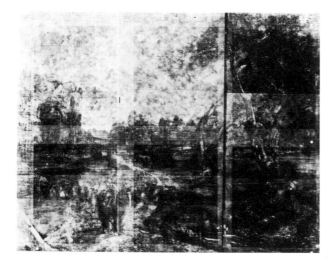

The x-radiograph of Flatford Mill

To Constable, colour was of supreme importance: 'I shall endeavour to get a pure and unaffected representation of the scenes that may employ me with respect to colour particularly and anything else – drawing I am pretty well master of'. But he felt the limitations of the artists' palette – 'When we speak of the perfection of Art, we must recollect what the materials are with which a painter contends with nature. For the light of the sun

he has but patent yellow and white lead – for the darkest shade, umber or soot'. This led to Constable developing a most personal style and technique, using texture and accents of pure white to capture more of the dews and freshness of nature. He went to great lengths to achieve the effects that he wanted in his paintings and 'Flatford Mill' is no exception. He made many preparatory sketches, worked for months on the exhibition picture, made numerous minor adjustments and finally repainted half of it. His standards were equally high in his selection and preparation of support, pigments and binding oils. Examination of 'Flatford Mill' and analysis of the paint admirably demonstrate Constable's considerable knowledge of artists' materials and understanding of their properties.

[1] Leslie Parris, *The Tate Gallery Constable Collection,* Tate Gallery, London, 1981
[2] Parris, Shields, Fleming-Williams, *John Constable: Further Documents and Correspondence,* Ipswich: Suffolk Records Society and Tate Gallery, London 1975
[3] Pigment analysis by T. Green, A. Southall – Tate Gallery and N. Eastaugh – Courtauld Institute.
[4] Walter Thornbury, *The Life of J.M.W. Turner, R.A., founded on letters and papers furnished by his friends and fellow accademicians,* Hurst and Blacket, London, 1862
[5] C.R. Leslie, *Life and letters of John Constable, R.A.,* Ed. R.C. Leslie, Chapman and Hall, London, 1896
[6] Media analysis by John Mills – National Gallery.
[7] Parris, *Tate Gallery Constable Collection* ibid.

SOURCES

R.B. Beckett, *John Constable's Correspondence,* 6 Vols, Ipswich: Suffolk Records Society 1962-8
R.B. Beckett, *John Constable's Discourses,* Ipswich: Suffolk Records Society 1970
John Walker (text), *Constable,* Thames and Hudson, London, 1979
Parris, Fleming-Williams, Shields, *Constable: Paintings, Watercolours, Drawings.* Tate Gallery Catalogue, London, 1976

SAMUEL PALMER 1805-1881

'Coming from Evening Church' 1830

Mixed Media on Paper 30.1 × 20 (11⁷/₈ × 7⁷/₈)

Samuel Palmer's reputation is based on a small body of visionary paintings and drawings of his Shoreham period (1825-33) during a long and productive life which did not end until 1881. He was the leading figure in the circle of 'Ancients' who looked to the past for literary, spiritual and artistic inspiration. These included George Richmond, painter; Francis Finch, watercolourist; John Giles, stockbroker and Palmer's cousin, and Edward Calvert, printmaker and later painter. This group had gathered round William Blake in his last years and after his death had centered their meetings for the expression of literary and visual ideas at Shoreham where Palmer moved in 1825. Here rural simplicity was presented to them in rude reality. Even though rustic life did not always live up to their ideal, it did provide a visual reference for the idyll that Palmer created there.

'Coming from Evening Church', painted in 1830, the apex of this period of visionary expression, is derived from the earlier 'A Hilly Scene' of 1826, also in the Tate Gallery collection. It has the full blown richness of other paintings of 1830 such as 'In a Shoreham Garden', now in the Victoria & Albert Museum. What is unusual about the painting is its technique and appearance. It is, according to an inscription on the canvas foldover edge, 'Painted in tempera (no oil)' which has always been accepted in catalogue entries. From Geoffrey Grigson's catalogue of Palmer's work between 1826-32, it seems that Palmer did not use any

method other than watercolour, ink and pencil with sometimes the addition of gouache, until a spate of tempera (and oil) painting from 1833-35, so 'Coming from Evening Church' seems technically to be an isolated work.

It was not until 1974 with the impending move of Palmer's paintings to the new Blake Gallery that a survey was carried out on all works to be hung in that Gallery. The Conservation Department was particularly anxious to see 'Coming from Evening Church' as increasingly disturbing cracks had developed in the thick glaze, and since small losses could also be noted. It is possible that there was cleavage between the layers. This seemed to be a continuing problem as the scant records which had been made in the past referred to 'laying and securing loose paint by Morrill' in 1922 and in 1940 when the painting was said to be already 'relined'. 'Crackle and blistering paint' were also noted before the picture went to war-time storage.

Initially, when removed from the frame it appeared that the catalogue description 'tempera on canvas which was relined to another canvas and stretched on a blind stretcher' was accurate. However, this would have been unusual as there is no other recorded painting by Palmer of this period on canvas (according to Grigson). The few early tempera and oil paintings are on wooden panel or paper laid on panel. More detailed examinations began to reveal that the construction of the painting was not as earlier examiners had thought. As

there was a piece of the support missing near the centre of the top edge, it was possible to look under the support with the aid of a microscope. The canvas attaching the painting to the stretcher was seen to be limited to the edge – it was not a relining. The actual support was a white paper of high quality with long fibres. There was, in fact, only strip lining to facilitate stretching and strengthen the edge.

The support therefore consists of a rectangular piece of white paper extended by the artist with narrow strips of paper glued to the reverse of the edges. A linen canvas strip lining has then been attached with glue to these additions (see diagram). The strip lining is unusual in that it is made from one piece of canvas with a central rectangle cut out. It could easily be mistaken for a complete lining after being restretched onto a new blind stretcher, as it undoubtedly has been. Original rust stained tack holes are in evidence on all foldover edges. The present attachment was most probably carried out by Morrill in 1922 as the original attachment was disintegrating due to rusting tacks.

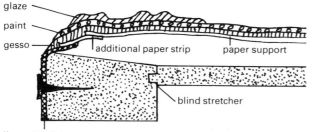

glaze
paint
gesso
additional paper strip paper support
blind stretcher
linen strip lining

Diagram showing the support and attachment

There is no doubt that the additions were made by the artist since the gesso ground, as well as the paint film, continues on to the canvas covering all the joins. Thus the so called 'painting on canvas' is in fact on paper which has been extended to accommodate design changes.

There are two inscriptions at the bottom of the painting; 'painted 1830 at Shoreham Kent S. Palmer' in gold, and on the bottom foldover edge 'Painted in Tempera (no oil) by Samuel Palmer at Shoreham Kent 1830' in ink, as mentioned previously. There is no certainty that either inscription is contemporary but as the painting remained in the family until it was bought by the Tate it seems unlikely that the inscriptions are erroneous or misleading.

As in the case of William Blake, the use of the term 'tempera' in the early nineteenth century did not necessarily indicate the use of egg as binding medium but a personal amalgam of glues and resins. So it was of interest to establish the structure of the paint film and the binding media used, and for help in this problem we are indebted to the Scientific Department of the National Gallery for the analysis of the samples.

It seems probable that the artist worked initially in sepia ink on a central piece of paper, to which a white gesso ground had been applied. He added colour to the landscape in transparent watercolour (the medium was found to be gum arabic). Then he worked up certain areas to an impasto using opaque pigments, for instance in the figures, moon and church spire, with size as a medium (gelatin was identified). At this stage Palmer wanted to incorporate the enclosing arch of trees. So he had to enlarge the support by adding the paper strips and the canvas strip lining, giving a greater surface area and allowing the whole assemblage to be attached to a stretcher. Having gessoed the

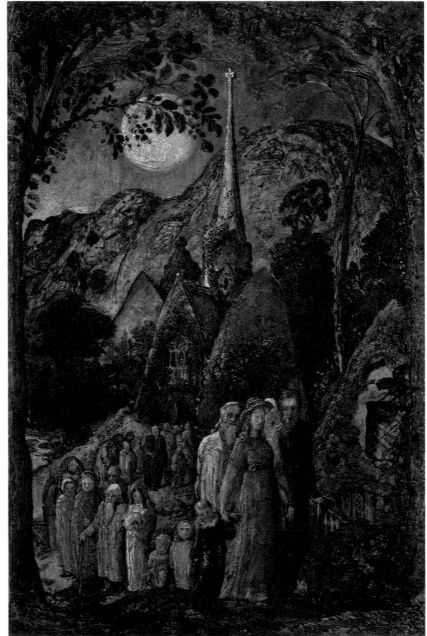

Samuel Palmer,
'Coming from Evening Church'
1830

extension, the design was continued in water-
colour and a unifying varnish applied. The design
was further embellished with gold powder mixed
with size.

Still seeking further unity and richness, he
added a final thick amber glazing to selected areas
which on analysis proved to be a mixture of rosin
and linseed oil emulsified with egg. These were
the typical constituents of household varnish at
the time so may have been the first thing which
came to hand with the properties he required.
This unorthodox material became very brittle
with time and as a result of mechanical stress, the
film cracked and delaminated, causing light to be
scattered across the fissures. The glaze was
marred, and the loss of transparency was visually
disturbing. Not surprisingly, this film was
unaffected by all normal reforming agents but on
the suggestion of the National Gallery Scientific
Department, dimethylformamide was applied and
it successfully rebonded the cracks and areas of
detachment, thus restoring the visual effect.

This examination established the painting as
being a work of unique construction and tech-
nique which is in original condition, apart from a
constituent in the final glaze and the addition of a
new blind stretcher. It is not painted in oil, as is
indeed claimed in the inscription. It is far more
consistent with this period of Samuel Palmer's
work, a watercolour on gessoed paper which was
enlarged and visually enriched by the addition of

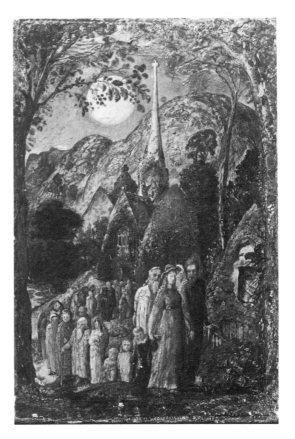

Early photograph showing damages

varnish, gold and an unusual final glaze using
household varnish.

NINETEENTH CENTURY SKETCHES AND UNFINISHED PAINTINGS

J.M.W. TURNER 1771-1851

'Goring Mill and Church' *c*.1806-7

Oil on Canvas 85.7 × 116.2 (33¾ × 45¾)

J.M.W. TURNER

'Rocky Bay with Figures' *c*.1828-30

Oil on Canvas 90.1 × 123.1 (35½ × 48½)

Turner was a prolific and successful water-colourist, combining the 'native' tradition of Sandby and Rowlandson with the 'Southern School' of the Cozens, father and son. Unlike Constable, who never left England, he was a great traveller. It is difficult to be definite about Turner's practices, but when working out of doors he seems to have used watercolours rather than oils. There are some exceptions, such as the large Thames oil sketches of 1806-7. 'Goring Mill and Church' is probably one of this group. Trimmer records: 'He had a boat at Richmond . . . From his boat he painted on a large canvas from nature. There are about two score of these large subjects rolled up and now national property'.

'Goring Mill and Church' is painted on a light brown canvas with a creamy off-white ground. The many creases (now retouched) of varying length and direction around all four edges suggest that the canvas remained unstretched for some-time. In the pre-1946 lining the tacking edges were

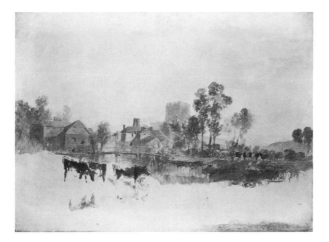

J.M.W. Turner, 'Goring Mill and Church' *c*.1806-7

J.M.W. Turner, 'Rocky Bay with Figures' *c*.1828-30

removed, making it impossible to determine how the damage was done. During this lining all areas of ground not covered by paint were partially or totally lost. They would have been thicker and creamier in colour and the heavy diagonal brush strokes would not have been so visible either. In places pencil outlines can be seen under the paint, but where not protected by the paint they were removed with the ground. It seems that Turner outlined the trees and buildings with pencil. He then painted in the sky with a blue wash followed by thicker white clouds, leaving the ground to be seen as sky through the trees. The painting of the trees over the dry ground is visibly different from that over the wet sky. He used a brush, possibly smoothing the smoke and the low cloud on the right with a thumb or palette knife. In the landscape, as in the sky, he mapped the colours and forms with flat washes of colour, using the paint so thinly that the brush marks are not visible. The buildings have thicker lights and darks but there is very little modelling in the trees. To the left of the pebble beach there is a water stain, probably the result of a leaking pipe in his studio rather than a boating accident. The sketch, being unfinished and not an exhibition painting, was not varnished.

This method of starting with the sky, working it to a light finish, and then painting the composition in terms of shape and tone can be seen in the later unfinished 'Rocky Bay with Figures'. It is a 3' × 4' canvas – a size Turner favoured for exhibition pictures – with an off-white ground. After painting the sky using brushes, knife and possibly fingers, he has smoothed and brushed broad areas of flat mid-tone colours to outline the rocky cliffs on the left, the sea, distant shore and boats, and the near beach. Over this he has brushed and knifed in stronger colours and textures, using thicker paint, although the rocks on the left were

smeared with a knife and very liquid raw umber – note the dried dribbles. The sky and the sea could be finished, but after this initial work Turner stacked another painting in front of it leaving a mark near the bottom in the wet paint, and never returned to rework it. His studio was full of barely started and half finished canvases, stacked round the walls.

SOURCES

W. Thornbury, *The Life of J.M.W. Turner, R.A., founded on letters and papers furnished by his friends and fellow academicians*, Hurst and Blackett, London, 1862

M. Butlin and E. Joll, *The Paintings of J.M.W. Turner*, Yale Univ. Press for the Paul Mellon Center for Studies in British Art, and the Tate Gallery, New Haven and London, 1977

FREDERICK GEORGE STEPHENS 1828-1907

'Mother and Child' *c.*1854

Oil on Canvas 47 × 64.1 (18½ × 25¼)

F.G. Stephens was a particular friend of Holman Hunt. He was a founder member of the Pre-Raphaelite Brotherhood, and worked with them for about four years before abandoning painting in favour of art criticism. Indeed he was so critical of his own work that he destroyed nearly all of it. He had very little training, but exhibited two portraits in the Royal Academy in 1852 and 1854. 'The Proposal' and 'Mother and Child' were found after his death, hidden behind some lumber in an attic. He must have forgotten them, as it seems certain he would have destroyed the unfinished 'Mother and Child'. The painting is on a medium weight linen canvas, with two layers of ground: an apparently coarser yellowish white layer, covered by a finer white layer. Both layers were analysed and

F.G. Stephens,
'Mother and Child'
c.1854

both contain lead white and chalk. Close examination reveals tiny hard particles that seem to have erupted through the upper ground and paint layers. Chemical tests were inconclusive but it is unlikely that these particles are glue from the first ground layer. It is possible that they are undissolved particles of resin from the varnish which Stephens mixed with his own white priming. This is in accordance with Holman Hunt's instructions and Stephens was a particular protégé of his. If the latter is the case, it raises the question of whether he painted over a freshly applied lead white primer. There is no evidence for this in 'Mother and Child'. The pencil drawing was executed on a dry surface; it is visible in the spandrels and under the transparent paint layers. He then painted with a small (probably sable) brush using thin pure colours. Like other Pre-Raphaelites he seems to have completed the painting of one area before moving to another, working round the finished areas if necessary. For instance, he painted the girl's white frock round the doll's red ribbon. When painting the lower left corner he finished it to the point of putting in his monogram, despite the fact that at least the candy striped bed cover was unfinished. It is possible that he prepared his paints himself with resin, turpentine and oil as a medium, testing them in the spandrels before using them on the painting. No analysis has been done on the pigments, but ultra-violet examination shows the use of rose madder for the bright pinks. The purples are probably cobalt violet, the greens emerald, the blues Prussian and the bright yellow is almost certainly Cadmium – Ford Madox Brown was using it ten years earlier[1].

Stephens seems to have found perspective difficult. He had trouble with the position and foreshortening of the girl's left arm. There are two pencilled positions below the present one which has itself been reworked. Most artists have a working knowledge of perspective even if they do not apply the rules rigidly. Stephens seems to have tried. There are lines leading from the mantlepiece into the left spandrel, annotated 'T. of cup', 'T. of saucer' etc. Here he has succeeded but the space in the room is confused by the incorrect drawing of the skirting board on the left, making the far wall look anything but parallel to the chimney breast. Further examination of the picture reveals other inaccuracies. It is tempting to speculate that the perfectionist Stephens realised there were inconsistencies and when attempts to improve them failed he abandoned the painting.

[1] Ed. Virginia Surtees, *The Diary of Ford Madox Brown,* Yale Univ. Press for the Paul Mellon Center for Studies in British Art, New Haven and London, 1981 p.32 Earliest reference to cadmium yellow is on 26 Feb. 1848

SOURCES

W. Holman-Hunt, *Pre-Raphaelitism and the Pre-Raphaelite Brotherhood,* 2nd Edition, Chapman and Hall, London, 1913
J.B. Manson (Notes), *Frederick George Stephens and the Pre-Raphaelite Brothers,* published privately by Donald McBeth *c.*1920

FORD MADOX BROWN 1821-1893

'Take your Son, Sir' ?1851-1892

Oil on Paper on Canvas 70.4 × 38.1 (27¾ × 15)

The unfinished state of this painting and its evidently complicated history demonstrate Brown's method of working most clearly. He used Reeves or Robersons prepared canvases and preferred a

Ford Madox Brown,
'Take your Son, Sir'
(?1851-92)

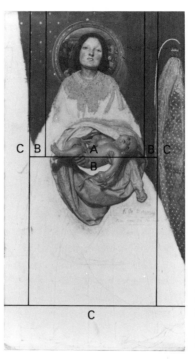

A diagram showing
seven separate pieces of
paper on one canvas.
A. original piece,
B. first three editions,
C. second three editions

lead white ground[1]. Over this he sketched an out-line in pencil and set to work to paint directly. Like Stephens, he used a small brush and quite a lot of medium[2], finishing one area before starting another. He liked to keep the paint layers thin, and if they became overworked, as when painting the baby, he scraped off some of the paint before working on the area a little more. He also used his brush end to draw in the wet paint. We know from his journal and other paintings that he frequently scraped off errors and re-applied a ground layer. This practice is most evident on 'Take your Son, Sir'. But he also changed his mind about the size of this painting, and probably the nature of the com-

position. It is impossible to establish how it fits together without taking cross-sections, but some sequence can be worked out by examining the picture closely.

The painting is on seven pieces of paper on canvas, later lined onto a linen canvas. Brown's journal indicates two enlargements to the original – 'A' in the diagram. The first was between 1854 and 1857, using three pieces of canvas with a more prominent weave pattern – 'B' in the diagram. In 1857 it was enlarged again using three pieces of smoother canvas – 'C' in the diagram. The evidence for how the support grew is easily visible in raking light. Less easy to see is the extent of each

ground layer. There were at least two applications: a white one over a yellower layer, now visible in the scraped area of the collar. The later white ground seems to have been applied after the last enlargement, covering all the joins and thinning out round the scraped areas. The pencil drawing is certainly all of a piece.

The history of the painting must have been something like this. On Section 'A' Brown did a study of Emma – now generally accepted to be the one he describes as 'with the head back laughing' in his diary for 1854. Of this the face and neck remain untouched, but the hair was repainted when the mirror was put in later. The collar has been scraped off. Tiny fragments of pink, blue and green paint remain, indicating a much more colourful collar than the one reflected in the mirror. The background to the head was scraped at the same time, but this has now been repainted, so no traces of the original colour are visible. There are also dark green fragments round the baby's shawl – probably the beginnings of a dark green dress. Was this a continuation of the costume started in the original study? The dark greens are the same. The area round the baby was scraped while the paint was still quite fresh, doing less damage to the ground. The paint on the collar was quite hard, and brought much of the ground layer off with it. The baby is painted on Sections 'A' and 'B', and relates very closely to a drawing in the British Museum. In 1857 Brown refers to painting in the baby, and sending the painting 'to be enlarged a second time, having made an error'. It must have been an error in judging the size of support he needed. If it was an error in painting he would have scraped it off. Following the second enlargement, Brown pencilled in the curtain and the dress, then painted in the green background, starting on the left and painting round the mirror,

over the scraped area and stopping to the right of it. The gold stars on this section give it a very finished look. But why did he stop here? There is a section of a circle over the mother's shoulder that was pale and in part yellow in colour. When he continued painting the background, Brown painted this area out. He also overpainted a strip above it, perhaps in an unsuccessful attempt to blend in the two areas. While the paint was still wet he scraped the green from the rod supporting the canopy to the cot, so that the white ground formed the base for his paint, not the darker green. The green background and the cot, which was lowered during painting, were the last areas to be touched by Ford Madox Brown. He never refers to this painting as 'Take your Son, Sir' in his journal. This was probably his rather than his son's title for the work, although it is unclear whether it was inscribed and signed by Brown or later by his son.

Thus a study of Emma's head and shoulders was changed to a full-length painting of a mother and child in two stages. It is a measure of the trouble and time Brown took over painting something to his satisfaction that he would adapt and re-use a fragment rather than starting afresh on a canvas of the right size. From the hours that he records in his diary, and the evidence of other paintings, he did not find his work easy.

[1] Ed. Virginia Surtees, *The Diary of Ford Madox Brown* In 1854 Brown states a preference for flake white and copal. He suggests that a particularly absorbent ground may be zinc white.
[2] Op cit.
Several entries refer to different mixtures for medium: e.g. copal varnish, copal and linseed oil in equal parts, copal and drying oil in equal parts, M'gilp (usually mastic in turpentine with linseed oil) and copal
He also used water colour on his oil paintings.

JOHN SINGER SARGENT 1856-1925

'Study of Mme Gautreau' *c.*1884

Oil on Canvas 206.4 × 108 (81¼ × 42½)

JOHN SINGER SARGENT

'Lady Fishing – Mrs Ormond' 1889

Oil on Canvas 185 × 97.8 (72¾ × 38½)

When first exhibited at the Paris Salon of 1884 'Madame X' caused a stir. Sargent experienced an unusual amount of difficulty with its execution, and despite many preparatory studies he reworked several areas of the painting. His reputation was for dashingly sure execution, and perhaps he felt the portrait was overworked. At a late stage he started again on a canvas identical in size, fine weave and off white ground. Copying his own painting would not have been difficult as he frequently copied old masters. But time ran out, the salon was due to open and the replica was not finished. So the original painting was exhibited, and the replica not touched again.

Sargent probably started painting 'Mme Gautreau' at the top of the canvas, putting in a thin wash for the background, and then mapping in the figure in flat areas of colour. In the face it is this brown underpainting that forms the shadows of the hairline, behind the ear, the neck, part of the chin and under the cheek bone. The texture of the ground shows through this thin layer, enhancing the effect of the shadow. The hair and the features were painted in at this stage too. Then came the lavender scumbles, the highlights on the jaw and the neck muscle, the shadows on the top of her left shoulder, the shaping of her bosom and arms, all modelled up in thicker denser paint. Where

Sargent changed an outline the background has been re-painted over the alteration, to neaten the edge. Had he continued, such differences in density would have been covered, as would the unexplained 'sketch' in the lower left corner, and the dabs and splashes of paint. This painting demonstrates admirably Carolus-Duran's teaching of five years before: 'Search for the half-tones, place your accents, then the highlights'.

From Paris Sargent moved to London, but returned to France frequently. He worked there with Monet in the late 1880s, and the influence of the Impressionists on his later work is clear. However, Monet told Rene Gimpel that Sargent was not himself a true Impressionist – 'One day the American painter Sargent came here to paint with me. I gave him my colours and he wanted black and I told him: "But I haven't any". "Then I can't paint," he cried and added, "How do you do it!"'. To the English, reared on a diet of Pre-Raphaelite precision and control, Sargent's free brush work seemed most modern and unfinished. Even worse, he could not draw! In 1887 'Carnation, Lily, Lily, Rose' was an unexpected success, and there followed a series of paintings of women and water, a theme explored by Monet at the same time. 'Lady Fishing' is one of this group, and is remarkably reminiscent of 'Mme Gautreau' in pose.

In 'Lady Fishing' Sargent appears to have used quite a large brush to put in broad flat areas of blue and white water. The formless mauve scumbles over the spikey grass must be a note of a colour or effect to be worked on later. Where the outline of the head or the sides of the skirt have been altered the painting out has been roughly done. 'Carnation, Lily, Lily, Rose' may look very impressionistic and swiftly executed, but in fact Sargent worked on it for a long time. This was in part because of the short time each day when the light was what

John Singer Sargent,
'Lady Fishing – Mrs Ormond' 1889

John Singer Sargent,
'Study of Mme Gautreau' c.1884

he wanted, but the painting also displays a considerable degree of finish. Compare the grasses in the two, or the care with which the dresses have been painted.

The crackle pattern indicates that 'Fishing' was rolled, paint film inside, before the paint was fully dry. It was probably tied at three points. Impressions of the canvas pattern in the paint film corroborate this. The paint extends over the fold-over edges, so the composition was probably larger originally. Whatever the history of the painting, it is unfinished, and like Turner's 'Rocky Bay with Figures', was probably the initial working, the result of one sitting on the banks of the river. All six of the paintings examined allow us an exciting and unusual insight into the artist's working methods. No methods of examination, even using photography, microscopes or x-rays, can show us quite so graphically what went on under the upper paint layers. We are fortunate, despite the lack of interest at the time, that so many unfinished works from the nineteenth century survive.

SOURCES

C.M. Mount, *John Singer Sargent: A biography*, W.W. Norton & Co. New York 1955

Richard Ormond, *John Singer Sargent: Paintings, Drawings, Watercolours*, Phaidon, London, 1970

John Singer Sargent in the Edwardian Days, Leeds, London and Detroit, 1979, Leeds City Art Galleries, National Portrait Gallery, London, Detroit Institute of Art. Catalogue.

J.M.W. TURNER 1775-1851 'Peace: Burial at Sea' 1841-42

Oil on Canvas 87 × 86.6 (34¼ × 34⅛)

At sixty-six, Turner was at the height of his career, an important member of the Royal Academy, with a long record of major oil paintings behind him. His old rival Sir David Wilkie had just died while returning from the Middle East and was buried at sea off the coast of Gibraltar[1]. Although the two artists had disagreed years earlier, Turner was genuinely moved by Wilkie's death so, in company with his crony George Jones, he sought to pay his respects to the deceased artist by painting a major work for the 1842 R.A. Exhibition. By now Turner's standing was very high and he chose to impress his fellow Academicians with a poetic work in light and colour, all detail and form reduced to allow unhindered expression. The black sails dominate the composition; the mood is funereal and sombre. Yet, although famous for his seascapes and marine painting, the artist has, in part, ignored the conventions and expectations of his contemporaries. Not surprisingly, the painting was poorly received, and even Ruskin, Turner's champion, chose largely to ignore it. In retrospect, this work appears to be remarkably progressive; in common with many of his unexhibited late oil sketches, it is now readily appreciated in the light of subsequent developments in art.

Initially Turner was a watercolourist. This is the medium in which he had been trained, with Girtin at Dr Monro's, and in which his early development had shown great promise. At first overshadowed by Girtin, he nevertheless kept pace with his contemporary and eventually recognised and developed his own abilities. The use of 'body-colour' on tinted paper and his 'colour-beginnings' in watercolour are perhaps Turner's most important contribution to painting[2]. Although it is evident from his tighter earlier works that he could be an extremely capable draughtsman, when sketching for his own records he would frequently dispense with the drawing and merely record the colours and highlights of a scene. This would enable him to compose a painting later on, incorporating a particular effect of light or atmosphere.

At this time, serious artists were expected to produce highly finished oil paintings and Turner soon found that he was able to excel in this medium too. Nevertheless, his unfinished works reveal that Turner began many oils using transparent washes in a manner similar to watercolour. An unfinished early oil sketch such as 'Goring Mill' (see 'Nineteenth Century Sketches' page 43) shows the strong influence of traditional watercolour technique. Later sketches, such as the 'Rocky Bay with Figures' and some of the unfinished works found in his studio at his death, show the influence of his watercolour 'colour beginnings'. They consist of thick brush strokes and the application by palette knife of white paint for the highlights and thin transparent washes of colour brushed onto an off-white or pale biscuit coloured ground.

There is good evidence to suggest that Turner began all his later oil paintings in this way. Having previously recorded the effects of light in watercolour studies on paper, he next transposed the essence of this image into oil on a primed canvas

A detail in raking light showing the *impasto*

and then added form and detail to produce a recognisable subject. This is an ideal method for the portrayal of sky, sea, smoke, mist and fire; all components of 'Peace: Burial at Sea'. If this caused him to struggle to fit the details into his overall plan, then that was of secondary importance, and increasingly he did not even bother. This painting is on a square canvas, but was exhibited in an octagonal frame so we have the opportunity to see that the corners are sketched to a less finished state consistent with the method described. Many of his works indicate two, or perhaps more, periods of working. The oil sketch would be put aside for a considerable length of time. (Some of these were never finished being left in his studio on his death, many showing signs of having being stacked wet.) Then Turner would return to the work, developing it to a state suitable for the Royal Academy with a lofty title and a high degree of 'finish'. Because of this working method, his paintings often suffer from the detaching of the top layers of paint from earlier layers. This is relatively unusual and cannot occur unless the underlayer of paint is fully dried before the next one is added.

Turner had a reputation for being mean, but at least he was prepared to take some trouble and expense over his painting supports. Frequently he used good cuts of mahogany for panels. These have survived well with little warping and no excessive moisture susceptibility. But of course mahogany from mature trees was readily available in the nineteenth century. Turner bought his later canvases already prepared from W. Brown of High Holborn, who also supplied Holman Hunt, known for his concern for permanence. These canvases were doubles, that is, two on one stretcher, the auxiliary canvas being primed on the reverse to protect the main painted canvas (see 'loose lining' Holman Hunt, page 57). Zinc coated steel tacks were used for attachment. These canvases have survived well, but despite this promising start, many of Turner's painting techniques are doubtful.

Turner was fortunate to live through a period of great discovery and technical development in artists' pigments. As a young watercolourist there was a restricted palette available, but soon chrome yellow was discovered. For the first time in history a strong yellow which was relatively permanent became readily available (by then blues and reds were not such a serious problem). In the hands of a colourist the effect was bound to be dramatic. Turner set about depicting the sun in all its aspects.

Many other pigments were developed, but for Turner these were mere luxuries; chrome yellow completed the spectrum for any competent painter. He is recorded as having found cobalt blue 'good enough' in comparison with French ultramarine which he used very sparingly. Analysis[3] of his painting box reveals several chrome yellows, cobalt blue and blue verditer (all noted by Thornbury[4]). The traditional pigments, chalk, Indian red, madder, yellow ochre, vermilion, Venetian red, and raw sienna were also found and various lakes and more fugitive materials such as gamboge, mercuric iodide, quercitron, carmine, possibly safflower and another more fugitive type of madder lake. Many of those pigments are reasonably stable but Turner seems to have been quite indiscriminate in their use. He took little interest in the technicalities of pigment manufacture and was dismissive of George Field, the chemist, but fortunately for Turner the new inorganic materials were generally sound, so he was free to explore aerial perspective and Goethe's theories.

However the same cannot be said for media. His

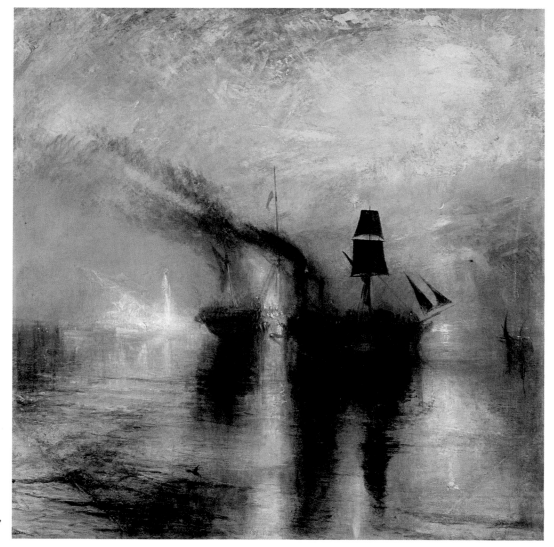

J.M.W. Turner,
'Peace: Burial at Sea'
1841

initial washes were probably oil, thinned with turpentine, brushed onto a quite absorbent ground. These have survived hardly changed, but the next layers may have quantities of media or of 'megilp' added to achieve translucent or transparent glazes, particularly evident in the sea (on the composition). Megilp is a mixture of oil and resin much used by Turner (see also Ford Madox Brown, page 46). Most of these glazes have darkened and yellowed by oxidation of the linoxyn and resin, seriously distorting the colour values. In addition some of these glazes are soluble in the solvents used for varnish removal and can be damaged in restoration.

Sir Joshua Reynolds, the first President of the Royal Academy, and Stubbs, both experimented with the use of wax with disastrous results. Turner seems to have used it in his later works, for instance 'Queen Mab's Cave', and Thornbury notes that a rose madder and blue mixed with wax was found in Turner's studio (the same colours as in the waxy wash on 'Queen Mab's Cave'). But this use of wax should not be overstated since it does not apply to most of his works.

Some of Turner's paintings have been reported to be cracked on first exhibition – once again he showed little concern for the problem.

On varnishing day, Turner came into his own. There are numerous stories of his activities, some suggesting he was willing to retouch on top of the varnish. It can be seen that this painting was to some extent finished in the frame. Unusually he chose to varnish with dammar, popular in Germany but not widely used in England where mastic was frequently employed. It is not known where he bought the dammar although some of his materials came from Newmans, the colourmen. Dammar is an excellent varnish which yellows more slowly than mastic, but Turner's painting technique has not made the inevitable job of varnish removal an easy task.

Parts of Turner's works have changed in colour and tone; his ambitious attempts to paint sources of light and ethereal phenomena have occasionally lost their subtlety, but sufficient remains for the viewer to appreciate what Turner has achieved. His imaginative use of colour, above all, sets him apart from his more restrained contemporaries.

[1] Martin Butlin and Evelyn Joll, *The Paintings of J.M.W. Turner*, Yale University Press, Connecticut, 1977
[2] Andrew Wilton, *Turner in the British Museum – Drawings and Watercolours*, British Museum Publications Ltd London, 1975
[3] N.W. Hanson, 'Some painting materials of J.M.W. Turner', *Studies in Conservation* Vol.I No.4 IIC London 1954, pp.162-173
[4] Walter Thornbury, *The Life of J.M.W. Turner*, Hurst & Blackett, London, 1862

WILLIAM HOLMAN HUNT 1827-1910
'Our English Coasts, 1852 (Strayed Sheep)'

Oil on Canvas, 43.2 × 58.4 (17 × 23)

For artists interested in the technical development of painting materials and the artistic techniques for which these materials were employed, the latter half of the nineteenth century provides a wealth of information and innovation. William Holman Hunt (1827-1910) was an artist who displayed such an interest and had the desire to experiment with both materials and techniques. Hunt was certainly familiar with the history of materials.

By the middle of the nineteenth century, scholarly works and translations of treatises on the history and materials of painting had been published. These works included Mrs Merrifield's translation of Cennino Cennini's treatise, 'Painting in Fresco, Secco, Oil and Distemper' (1844) and 'Original Treatises in the Arts of Painting' (1849). Further works were Charles Eastlake's 'Materials for a History of Oil Painting' (1847), and R. Hendri's translation of Theophilus' 'Essay Upon Various Arts' (1847). The various treatises explained in great detail the nature of pigments, oils and resins and the methods of manufacture and usage.

Although not a chemist and never claiming to understand the complexities of the chemical field, Hunt was in correspondence with several eminent chemists, including Frederick Barff, George Field, and Dr Sim. Frederick Barff was an assistant professor of Chemistry at University College, London and was interested in the nature of colour and pigment. In 1870 he delivered a series of lectures on artists' colours and pigments to members of the Royal Society of Arts. By 1838 George Field had already published several books on colour and pigments and his experiments with pigments eventually led to the manufacture of pigments of high quality and purity, bearing his name. Hunt's correspondence and diary entries reveal the extent to which he relied on the chemist's evaluation of pigments, particularly the recently developed pigments, and the quality of Field's pigments.

Many new pigments were introduced in the nineteenth century. Frequently the discovery of a new element or chemical compound eventually led to the development of a corresponding new pigment. Most spectacularly, newly discovered chromium found its way into the artist's palette as chrome red and chrome yellow pigments. Other new pigments included cadmium yellow, cerulean blue, cobalt blue, cobalt green, cobalt yellow, emerald green, ultramarine violet, viridian and the vast range of colours based on the coal tar derivative, aniline. One range of coal tar derivatives, referred to as the alizarins was to replace the natural madders. But as Hunt was to discover, either through the changes in pigments in his own paintings or through experimentation, some of the new pigments were not particularly stable or lightfast.

Hunt was a founding member of the Pre-Raphaelite Brotherhood. The bonds of the

Brotherhood were cemented by agreement on moral philosophy and a kinship with the Italian painting style before Raphael. It was Hunt's interest in the technique of the Italian masters and the mastery of their crafts which set Hunt apart from other members of the Brotherhood.

In the painting, 'Our English Coasts, 1852 (Strayed Sheep)', the technical and craft aspects which influenced Hunt are skilfully manipulated to create the visual image he desired. The painting is on a canvas support which is backed by another canvas, primed on the reverse. This second canvas acts as a moisture barrier thereby lessening the effect of humidity on the original canvas. This was a device employed by a number of artists' colourmen (see Turner page 52). In this case both canvases have commercially applied primings suggesting they were purchased ready stretched.

Although the painting canvas has a commercially applied priming, it is interesting to know that a second separate priming of lead white may have been locally applied to the canvas. Both Hunt and his fellow Brotherhood artist, Millais, had separately devised a technique for producing a particularly notable brilliance of colour. Hunt explains this technique as follows:

'. . . on the morning for the painting, with fresh white (from which all superfluous oil has been extracted by means of absorbent paper, and to which a small drop of varnish has been added) spread a further coat very evenly with a palette knife over the part for the day's work, of such density that the drawing should faintly show through. Over this wet ground, the colour (transparent and semi-transparent) should be laid with light sable brushes, and the touches must be made so tenderly that the ground below shall not be worked up, yet so far enticed to blend with the superimposed tints . . .'[1].

Certainly the brilliance of the colour in this painting suggests that this technique may have been used. It appears that semi-transparent yellow pigment and a reddish brown pigment may have been lightly applied to the surface of the wet priming to block in the forms of the sheep and the ground of the vegetation. Faint pencil lines are also visible as part of the preparatory sketch. The forms of the sheep and vegetation were then built up through the use of consecutive layers of either opaque or transparent paint.

This crispness of brush stroke and the enamel like quality of the paint is characteristic of many of Hunt's paintings. The thickness of a paint stroke is determined by the quantity and the type of oil and/or resin in the painting medium. Not only had Hunt familiarised himself with the materials of the Old Masters but he had also conducted experiments based on their recipes or formulation. It appears that he finally selected a painting medium consisting of equal quantities of poppy or walnut oil, copal varnish resin and rectified spirits of turpentine[2]. The advantage of this painting medium would be the buttery consistency of the paint during application and the enamel-like quality of the paint surface upon drying. Certainly the crisp brush stroke and buttery consistency of the paint is visible in the sheep's coats and the leaves of the vegetation. Other sections of the painting are constructed by the use of transparent glazes over a white or coloured foundation. The delicate crimson flowers in the foreground are created over a white undercoat. Hunt's technique was quite precise, allowing no alteration or reworking.

The most startling aspect of the painting is the flamboyant use of brilliant greens and purples. The use of brilliant green highlights in the landscape and the deep purples and blues in the shadows was an unusual innovation. In colour

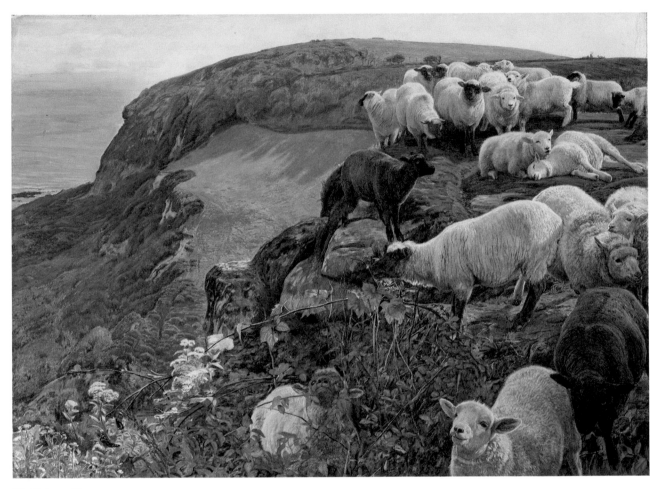

W. Holman Hunt,
'Our English Coasts
(Strayed Sheep)' 1852

theory, green and purple are complementary colours and balance each other but to the eye of nineteenth-century observers, it was a startling contrast. If one compares Hunt's painting with another contemporary artist (not of the Brotherhood) such as William Frith, the difference in approach is immediately obvious. In Frith's painting, 'Derby Day' (1856 – 1858), the shadows are merely darker shades of the adjacent colour and the highlights a lighter shade. But to Hunt, the shadows and highlights were not mere shades of their former selves but vivid colours. The new pigments, particularly the enlarged range of purples, were to provide Hunt with a means of innovation. Ruskin was to refer to this painting several years later as 'showing us for the first time in the history of art, the absolutely faithful balance of colour and shade by which sunshine might be transported into a key in which the harmonies possible with pigments should yet produce the same impressions on the mind which were caused by the light itself.'[3].

Hunt was later to become suspicious of the new purples, particularly the synthetic alizarins. His experiments revealed that they were not lightfast and he devised a method of protecting their lightfastness by isolating them in a layer of poppy oil. His interest in the quality of pigments became a major focus in the latter part of his life. In the following paragraph Hunt summarizes his concerns.

'In the year 1880, feeling seriously that the evil was not only great, but that the consequences of ignorance were increasing, I applied to the Society of Arts for an opportunity to demonstrate this, I gave an address on the subject, and carried on the discussion which arose afterwards. I feel now that much good was done in convincing artists and colourmen of the danger of blind trust in the unnoticed supply of the day. It transpired that the producers of colours were no longer small manufacturers superintending all their preparations personally; these had been supplanted by the proprietors of large factories, where each production goes through numerous irresponsible hands. A full ventilation of the subject induced retailers, accordingly, to become more cautious than they had been of recent years in receiving materials from the wholesale dealer.'[4].

At no time did Hunt wish to blame the colourmen, he merely urged that standards be established for the maintenance of the quality of artists' materials.

As has been demonstrated, Hunt was influenced by and involved in the various technical aspects of an artist's work, yet one must not lose sight of the artist's primary purpose – to convey visually an idea or an impression. In 'Strayed Sheep' (or 'Our English Coasts'), Hunt certainly succeeds in capturing the quality of sunlight on a lush green landscape. His minute rendering of vegetation and the thick coats of sheep are almost photographic in appearance. Undoubtedly, his understanding of materials and his experimentation with, and incorporation of new pigments has allowed him to express his ideas in an original and permanent way.

[1] William Holman Hunt, *Pre-Raphaelitism and the Pre-Raphaelite Brotherhood,* 2 Vols Chapman and Hall, London, 1913 Vol.I p.198

[2] Leslie Irwin, *The Painting Materials and Techniques of William Holman Hunt,* Courtauld Institute diploma paper 1977

[3] Timothy Hilton, *The Pre-Raphaelites,* Thames and Hudson, London 1970, p.136

[4] William Holman Hunt, *Pre-Raphaelitism and the Pre-Raphaelite Brotherhood,* 2 Vols Chapman and Hall, London, 1905, Vol.II p.454

J. A. McN. WHISTLER 1834-1903

'Miss Cicely Alexander: Harmony in Grey and Green' 1872

Oil on Canvas 190.2 × 97.8 (74⅞ × 38½)

Whistler accepted the commission for this portrait soon after he had finished the outstanding painting of his mother and while he was still working on the portrait of Thomas Carlyle. He had originally intended to paint all the Alexander sisters. However, it took seventy sittings to complete the portrait of Miss Cicely, leaving both artist and sitter exhausted[1]. Plans were made for the next sister, Miss May, but these were never carried out so now only this portrait remains. Nevertheless, the result is one of Whistler's most successful works.

Whistler was a perfectionist and his method of painting proved to be very demanding on the sitter. The pouting lips and weary expression are those of an uncomfortable little girl forced to stand for hours on end in the same position whilst the artist, absorbed in his work, failed regularly to notice lunchtime becoming teatime. Whistler suffered too, frequently having to rub out and alter his composition. Why did such a seemingly simple portrait take so much time? The painting is subtitled a 'Harmony in Grey and Green' reflecting Whistler's interest in the subtle modulation of both tone and hue. Miss Alexander had to be portrayed quite accurately, yet she was essentially the victim of Whistler's overriding need to reconcile the often conflicting demands made by his aesthetic approach. Somehow he had to introduce decorative elements taken from Japanese prints, (recently brought to the west), the pose and style of a Velasquez, whom Whistler greatly admired, and his own restricting tonal and colour harmonies. If he failed to introduce all these elements at one sitting then he would rub out large parts and start again. He even went so far as to give Mrs Alexander directions on the quality of the muslin for the gown, where it was to be bought, details of the frills, the ruffles at the neck, the ribbon bows and even the way the gown was to be laundered.

A small sketch of Cicely is the only preparation that Whistler is known to have made (now in a private collection[2]). He began his work at his Chelsea studio by preparing a relatively fine linen canvas (18 warp and 18 weft threads per cm) which contained many knots and coarse threads. The canvas was subsequently lined in 1942 when the original stretcher and canvas tacking edges were removed, so now there is little evidence of the original condition of the support, although a light vertical line at the bottom right-hand side of the composition indicates the inner edge of the original stretcher. Some of the knots visible from the front are caused by the lining canvas pattern being impressed into the original during the glue lining. Nevertheless, it is reasonable to assume that the texture of the canvas was intended to be seen in the finished work, and that Whistler applied his paint layers thinly to avoid hiding the texture completely. This is most easily seen in the semi-raking light detail and can be confirmed by other paintings by Whistler in the Tate's collection, most of which display the same texture.

Beginning with this irregular canvas, the artist

first applied a priming layer. He had been experimenting with his nocturnes and in these and most of his portraits he chose to apply a thin dark grey priming which would define the overall tone of the painting. Walter Greaves, who frequently prepared his canvases, describes Whistler's priming as being 'absorbent and distemper', which probably means rabbitskin glue, similar to the size normally applied to the unprimed canvas, mixed with pigment to form a lean mixture, that is, with excess pigment. The priming was applied thinly and evenly, just filling the interstices of the canvas weave. In this case his repeated rubbing down thinned the layer further, at places exposing the canvas threads.

Whistler's choice of an absorbent priming allowed him to apply thin washes and scumbles of oil paint, diluted with turpentine, to construct his composition. In this way the colour merely stained the priming leaving a thin matt film, which is still evident in the dado. Hence he followed the sound technique of applying richer paint on top of a leaner layer which, when applied thinly, produced a stable result. In this painting there are no disturbing cracks in the background areas, just a very fine, hardly visible, crack pattern.

With the exception of vermilion for the lips, and possibly cobalt blue in the greens, the artist has used a very restricted palette of black, white, siennas, umbers and ochres, yet the delicately applied areas of pure colour scattered around the composition stand out strongly against the subtle variations in the greys. Generally, he arranged the paint on his oval palette with white on the top edge, the yellow and earth colours spread out on the left, the reds and blacks on the right, mixing a large amount of his chosen colours in the middle and adding copious quantities of turpentine to produce what he called his 'source'. Gradations of flesh tones and shades were prepared and only when the full range of colours and tones were complete would he transfer any paint to the canvas. This was done using a large number of brushes. House painters' brushes were suitable for the washes and long-handled hogshair brushes, each one fully charged with a dominant colour, for the more precise work. After such preparation, the art of painting was swift and spontaneous until he became dissatisfied, rubbed it all out, and started again on the next sitting.

In the floor and walls of the composition Whistler's grey tones have been built up by adding successive coats of grey paint to the darker priming. Beginning with a dark priming and then brushing lighter scumbles on top inevitably produces cool tones owing to the scatter of light within the paint film. This is a well-known effect. Similar phenomena are frequently observed in nature, for instance, fine smoke particles appear brown against a light sky and blue against a dark background. Whistler probably used a white and raw umber mixture which is cool and dark where it is thinly applied, becoming lighter and warmer as the paint layers are built up. This effect is also seen in the robe on the chair to the left.

The figure was painted slightly differently, involving a more thickly applied white paint, brushed to a low impasto in order to obliterate the dark layers. But even here the semi-transparent nature of the muslin and feather are illustrated by painting them thinly to reveal the form of the underlying figure. Of course the paint film has since become more transparent than when the work was just completed, so some of these effects are now more apparent than was originally intended. In particular, it is possible to see alterations to the position of Miss Cicely's feet, arms, left hand and the grey muslin.

James Abbot McNeill Whistler,
'Miss Cicely Alexander:
Harmony in Grey and Green'
1872

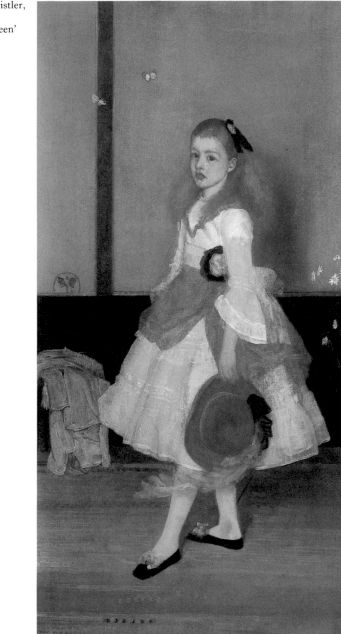

A detail in raking light to show the canvas texture
and brushmarks

So far most of the painting had been very free,
but the face had to be painted to a more finished

state, in order to be acceptable to contemporary
observers. Even here we can see (in the detail) that
the highlights overlay the shadows. The green
sash, black rosette and ribbons, the flowers and
butterflies provide the decorative elements to
complete the harmony and Whistler's butterfly
motif identifies the artist.

The varnish applied to the painting would have
been a soft resin such as mastic in turpentine.
Unfortunately yellowing of this and a more recent-
ly applied varnish had a disastrous effect on the
painting, causing difficulty in discerning the all
important difference between the greys and
greens. The problem was resolved by removing
these varnishes and replacing them with an acrylic
varnish which should not discolour as quickly.
The painting is set in a gold frame with fluted
moulding, typical of Whistler's design.

On completion, Tom Taylor, the critic of 'The
Times', observed that the upright line in the
panelling of the wall was wrong and that the por-
trait would be improved without it. 'Of course' he
added 'it's a matter of taste'. Whistler characteris-
tically replied 'it's not a matter of taste at all, it's a
matter of knowledge'.

[1] E. R. & J. Penell, *Life of James McNeill Whistler*, Vols I & II
Heinemann, London 1908
[2] Andrew McLaren Young, *The Paintings of James McNeill
Whistler*, Yale University Press, London, 1980

LUKE FILDES R.A. 1844-1927 'The Doctor' 1890-91

Oil on Canvas, 166.4 × 242 (65½ × 95¼)

The painting was begun in 1890 and finished early in 1891, less than a fortnight before it was exhibited at the Royal Academy. Sir Henry Tate then purchased it for three thousand pounds and included it among fifty-seven paintings he offered as a gift to the nation.

The inspiration for the painting came from an event in Luke Fildes' life, thirteen years earlier. His son Philip had become ill and died on Christmas Day. The professional devotion of Dr Murray, who attended the child during his illness, had made such a deep impression on Fildes and his wife, that he said 'the painting was to put on record the status of the doctor of our time.'

The figure of the doctor was not a portrait of Dr Murray, but a composite of several medical friends of Fildes, principally Dr Thomas Buzzard, and also a professional model. Fildes spent a week in Devon sketching fisherman's cottages and then constructed a full size interior of a cottage in his London studio as a setting for the scene of the painting. He made only a few preliminary studies before beginning the painting. It was one of his biggest pictures and the easiest and quickest painted[1].

The support for the painting is one piece of plain weave linen canvas ($^{15}/_{16}$ warp and weft threads per cm.). The canvas is stretched on a pine wood stretcher which is constructed from seven bar members (width 3¾'', thickness $^7/_8$''). The four side members have traditional open mortise and tenon corner joints with two expansion keys each. There is one central vertical cross-member

The artist's colourmaker's stamp on the reverse of canvas

and on either side, a central horizontal cross-member. What is interesting about this stretcher is the presence of four solid wood panels filling in the areas between the bar members. They are attached to these members by unfixed tongue and groove joins, thus still allowing the stretcher to be expanded. They fit flush with the front of the unchamfered bar members and are about $^1/_8$'' thinner.

Stretchers with these panel members were often made in the nineteenth century and are now known as 'blind' stretchers. As well as making the stretcher stronger, they have been shown to reduce the rate of deterioration of the canvas (see loose lining, page 52 and page 57 and also Samuel Palmer article, page 39).

The canvas and almost certainly the stretcher, were purchased from Charles Roberson. The artists' colourmakers stamp is on the reverse of the canvas. This was revealed during the recent

restoration of the painting. Robersons were a colourmakers popular with many leading artists in the nineteenth century and they are still trading today.

Information received from Roberson's relating to another painting in the Tate collection ('Derby Day' Cat.No.615 by W.P. Frith) for which they prepared the canvas, reveals that – 'Canvases were always primed firstly with two coats of glue size, then a coat of a mixture of white lead, whiting, boiled and raw linseed oils, thinned with turpentine, then a second coat of pure white lead in oil base thinned with turpentine. The lead, when obtainable, was prepared by the Stack Process as this, due to the varying size of the particles, gave an acceptable tooth to the surface.' It is therefore possible that the priming for the painting of 'The Doctor' is of a similar composition. It has a 'stippled' textured surface and old Roberson's catalogues state that 'grounds', specially prepared, could be made to order with extra surfaces, either smooth or granular. It would appear that this ground is one of these. Research carried out[2] on Roberson's 'stippled grounds' shows that there were seven types available, ranging from fine No. 1 stippled to very coarse No. 7 stippled. Comparing this one with Roberson's samples it appears that it is about No.2 or No.3 stippled.

As Fildes bought his stretcher and canvas from Roberson's, it is quite likely he also obtained his

A textured ground from Robersons

paints, media and other equipment from them. Roberson's paints included oil/resin paint mixtures (e.g. amber colours) as well as standard oil colours. Their oil painting medium was a mixture of copal varnish, pale drying oil and mastic varnish. It was advertised as 'imparting a lasting brilliance to oil colours'. It is very likely that Fildes would have used some of these in his painting of 'The Doctor'. From Fildes' own accounts, between 1882 and 1894, it is interesting to note that he purchased a variety of media. The account reads as follows:

5 bottles of poppy seed oil at 6d each
1 bottle of poppy seed oil at 1/-
3 bottles of copal a l'huile at 2/6 each
1 bottle of pale amber varnish at 3/-
1 bottle of pale amber varnish at 4/-
1 bottle of pale amber varnish at 4/6
2 bottles of varnish (unspecified) at 3/- each
Rectified turpentine and various tubes of paint including six tubes of bleu de lumiere and vert de gris at 12/-.

Therefore on occasions he would have added these extra media to his paints.

The painting was begun by applying thin, lean paint diluted with turpentine to sketch in and indicate the different shapes and areas of the composition. Thicker paint containing more medium was then applied, defining the figures and objects more fully, and also the general colours and tones in the contrasting areas of light and dark. The paint was applied freely with wide hogshair brushes (these brush markings can be seen clearly in the dried paint in places). Many areas were reworked at this stage, the outlines and the colours being adjusted to develop the composition. The paint probably contained varying amounts of resin and oil to achieve the variety of layers and thicknesses. The texture and 'dryish' quality of the paint in the thickest areas, mostly those of white

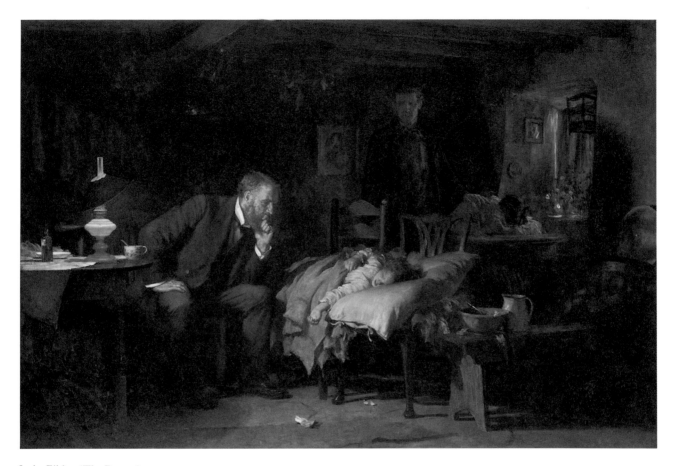

Luke Fildes, 'The Doctor'
*exh.*1891

paint (i.e. the doctor's head and hands and the child and bedding), indicate the possible additions of poppy oil which gives the wet paint a buttery consistency.

The sharp contrasts between light and dark areas result from three direct sources of light within the painting. The warm light comes from two places; firstly the lamp on the table and secondly as if from a fire place, directly in front of the painting. These highlight the figures of the doctor, child and the child's bedding plus the tables, chairs and floor giving them all brown, yellow, red and pink colours, complemented by blue in the shadows. The third source is the cool dawn light coming through the window on the right, lighting mainly the window area itself and the two figures in the background, with cool blues and greens. The rest of the room is in deep shadows mainly of dark blues, blacks with some browns.

The subtle mingling of the warm and cool light and the finer complex modulations of colour and tone, are achieved with further applications of paint, using finer brushes, applied in the form of scumbles, glazes and some impasto. Many of these appear to contain a fair proportion of resinous medium to give a greater variation to the transparency and thickness of the layers.

The stippled texture of the ground is visible on the surface of the paint in many places, particularly if viewed with a semi-raking light. There appears to be no obvious reason why Fildes chose this type of ground for the painting. One can only suppose he liked the texture to paint on. The resin content in the paint will have yellowed and darkened with time, so that the balance of the colours will have changed, but to what extent it is difficult to assess. After the painting was finished, a general layer of varnish was applied (probably mastic or dammar resin) to saturate the colours and give a 'glossy' finish to the paint. This also would have yellowed and darkened, further changing the colours of the paint.

The painting was finished in the frame. This is known from a drawing done at the time in Fildes studio and reproduced in 'The Art Journal' of 1891. This original frame of wood and gilded plaster moulding had been removed sometime in the past. It has since been restored and the painting returned to it. This is as it hangs today, a good example of late Victorian genre painting.

Fildes said in a letter to a friend, just before it went to the Royal Academy in 1891 – 'of course it is far short of what it ought to be and what I know I could do – but there, it will have to go . . . Mr. Tate saw it for the first time last week and I believe likes it . . .'[3].

1 L.V. Fildes, *Luke Fildes R.A., a Victorian Painter,* Michael Joseph, London, 1968, p.118
2 Unpublished research by Alec Cobbe, Hamilton Kerr Institute, Whittlesford, Cambridge, 1970-82
3 Op.cit., L. V. Fildes, p.121

Luke Fildes painting 'The Doctor' in his studio, from a sketch in the *Art Journal* 1891

W.R. SICKERT 1860-1942

'The Interior of St. Mark's Venice' 1896

Oil on Canvas, 70 × 49.2 (27½ × 19³/₈)

'On cold days I do interiors of St. Marks' wrote Sickert to Wilson Steer in 1895. This particular painting is dated 1896 with rather more certainty than many of Sickert's exteriors. For instance, the individual paintings which form the series of views of St Mark's façade are unusually difficult to date because many were completed, and most probably started, long after the artist had left Venice. The freshly handled paint and generally small brushmarks of the 'interior' bring to mind the paintings of the Impressionists but the colouring was a far cry from their bright optical mixtures. The Impressionist would avoid the use of black, applying his paint to the canvas in small dabs of almost pure colour leaving the eye of the viewer to blend the colours. Sickert spat into the wind of current radical fashion by making his initial drawing in black and subsequently using a colour scheme that can in honesty only be categorised as brown. The illusion of this work having been painted in St Marks is strong but Sickert was adept at, and strived for, a feeling of apparent spontaneity in his brushwork which was, however, usually the result of a carefully considered response to his drawings, smaller oil sketches and even photographs in his studio. An admirer of Sickert is bound to make a comparison between this view of a large public building interior and those of the London music halls. He had begun to solve many of the problems associated with the rendering of theatrical interiors before he came to Venice but the chance to tackle similar problems in a larger but similarly decorated church interior were obviously not to be missed – particularly on a cold day!

The support chosen by Sickert was a closely woven linen canvas attached to a four member stretcher. Not long after being painted the canvas was removed from the stretcher and a 'lining' canvas of cotton was stuck to the reverse of the original canvas. The usual reason for undertaking a lining is to strengthen an original canvas in the event of its edges splitting. However, the tacking margin of the original canvas remains quite strong even today with the lining canvas serving no apparent function other than as an irritant to art historians who would prefer to be able to examine the reverse of the original for evidence of canvas inscriptions, customs stamps and 'colourmakers' marks. Sickert himself obscured the reverse of another Venetian scene, that of 'The Salute' (Tate Cat.No.5093) with a water soluble creamy coloured paint which however only partly hides the canvas stamp of the London colourman Cornelissen.

The canvas used by Sickert for the 'Interior of St. Mark's' bore a thin white priming over which he laid, in this instance, a hastily brushmarked grey oil imprimatura, the streakiness of which allowed the white of the priming to remain partially visible. Both amateur and professional painters know the apparent but deceptive darkness of the first brushmarks of colour applied to a white primed surface and it was to avoid this unneces-

sary difficulty in gauging the tonal accuracy of subsequently applied paint that persuaded Sickert to continue for several years to use the priming colour that had been advocated by Whistler. Onto this cool mid-toned priming, then, he drew with the tip of a relatively pointed hog-hair brush the position of the basic architectural forms. He used a black paint for this, most probably made a little more fluid by the addition of turpentine or the petroleum distillate which is now generally known in England as White Spirit or Turpentine Substitute. Notice of a 'Patent Turpentine' had been lodged in 1885 and in a letter to Whistler of the same year Sickert had enthused about the qualities of a 'Petroleum oil' as an alternative to Turpentine. In the same letter Sickert mentions the addition of this thinner to 'burnt oil' (a half-dried, thickened linseed oil) and although many of Sickert's enthusiasms were notoriously shortlived there is no reason to suppose that he had forsaken this useful painting medium when he came to paint the 'Interior of St. Mark's'. The general tonality and mood of the interior were established with a tapestry of dabs, swirls and blotches in earth colours ranging from the cooler hues of raw umber and light red to the warmer Indian red and burnt umber mixtures. Some of the more prominent architectural features in the middle ground were indicated in relatively cool light brown paint mixtures, their coolness dictated by the splash of light on the floor which formed the main source of illumination. The vigour with which Sickert described this floor area, with a well loaded brush repeatedly scudding across the picture surface, is in direct relation to its importance as a light source. Indeed this carefully prepared relationship between areas of different brushwork constitutes the basis of most Sickert paintings. The tone of this splash of light was chosen with similar care.

It needed to provide a pictorial foundation for the soaring forms of the church architecture; it needed to provide a stabilising effect both for the flickering dabs of colour used to suggest the frescoes and gilt decoration, and also for the windows in the dome and apse which would otherwise tend to 'float'. The final touches to the painting included the softening of the outline of the apse window and the slight addition of blue to the other windows. Sickert's introduction of the blue figure at the side of the picture emphasised the gloom of the shadowed area under the arch, providing scale and the necessary colour link with the small blue accents used elsewhere in the picture.

The painting's surface was given a coat of natural resin varnish at least forty years ago. We cannot be sure who applied this varnish but the dark tonality of the painting in general and the subtle colour variations in the darker passages would have benefited enormously by the wetting action (the saturation) of the varnish after initial sinking of the paint medium. Conversely, Sickert painted some of his later light toned pictures with relatively little oil medium to bind the pigment (giving a pastel-like effect) and these have been deliberately left without varnish. The varnish on the 'Interior' has now yellowed slightly but is not yet considered to be affecting the appearance of the picture adversely.

The present frame is the one in which the painting was acquired by the Tate Gallery in 1941. It has straight mouldings, two orders of which are of low carved relief. The frame is painted with a raw umber colour which is then scumbled over with a warm grey. The provenance of the frame is not recorded but the rustic Italianate effect is thought to be appropriate.

Although Sickert adopted several styles of painting during the course of his life, the 'Interior

W.R. Sickert, 'Interior of
St. Mark's, Venice' 1896

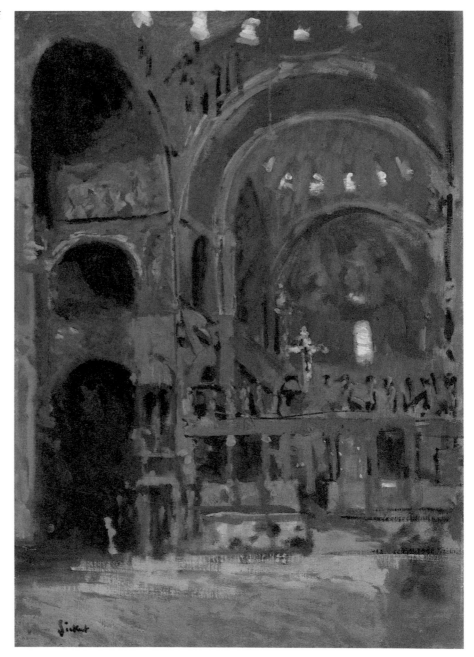

of St. Mark's' cannot be said to be typical of any one of them. It does however come well within the scope of Dr Wendy Baron's reference to this artist's 'lifelong fastidious reaction to the matter and substance of paint'.

W.R. Sickert, 'St. Mark's, Venice: Pax Tibi Marce Evangelista Meus' 1895-6

Included in the Tate Gallery collection of Sickerts are many with a related technique. Three of the most relevant are:

'St. Mark's' (the façade) Tate No.5914 of 1895-6 in a more laboured style with dark architecture, rich colour and yellow/green sky.

'Les Arcades de la Poissonnerie, Dieppe' Tate No. 5045, circa 1900 of similar concept, laboured style, rich colour, yellow/green sky, grey ground (see 5914).

'Venice, la Salute' Tate No.5093, circa 1901-3, with a grey ground, yellow/green sky but in a very much lighter, more open Impressionist style than 5045 or 5914.

SOURCES

Wendy Baron, *Sickert,* Phaidon, London, 1973
Marjorie Lilly, *Sickert: The Painter and His Circle,* Elek Books, London, 1971
Rutherford J. Gettens and George L. Stout, *Painting Materials: A Short Encyclopaedia,* Dover Publications, New York 1966
Mary Chamot, Dennis Farr and Martin Butlin, *The Modern British Paintings, Drawings and Sculpture,* Vol.II Oldbourne Press, London 1965

PAUL CÉZANNE 1839-1906 'The Gardener' 1906

Oil on Canvas, 65.4 × 55 (25¾ × 21⅝)

'Your father has been ill since Monday . . . he remained outside in the rain for several hours. He was brought back in a laundry cart, and two men had to carry him up to his bed. The next day, early in the morning, he went into the garden to work under the lime tree, on a portrait of Vallier, he came back dying'[1]

This portrait of Vallier is one of a series of three watercolours and three oil paintings that Cézanne had been painting in the garden of his studio at Les Lauves. In 1901 Cézanne had acquired a small property half way up a hill to the north of the town of Aix. Here he constructed a two-storey structure which contained small rooms on the ground floor and a large studio on the first floor. In front of the studio, a small garden bordered the property and it was this garden that the old gardener, Vallier, tended[2].

In the painting, Vallier is seated in the court-yard of Cézanne's studio under the lush canopy of the lime tree. The portrait is painted on a very fine and closely woven linen canvas which has a commercially prepared ground of lead white. The texture of the canvas is almost non-existent even in the area where paint has been applied in thin washes. Although Cézanne had previously used toned grounds, he began to use a white ground in the latter years of his life. As in the watercolour technique, the white ground remains exposed in several areas, being incorporated into the final painting as highlights. In oil painting, as in water-colours, passages of colour (particularly thin washes of colour) acquire a brilliant luminosity when placed over a white ground.

The painting is constructed with successive layers of short overlapping strokes of colour. In earlier works, Cézanne had applied short brick-like strokes of paint with a palette knife, but he discards this method and returns to the use of a brush in this later work. The thickness of the paint film varies from a fluid, full bodied rhythmic brushstroke to a thin veil-like wash. The actual paint surface never becomes thick or multilayered as in the more traditional method of structured underlayers and overlayers of opaque paint and transparent glazes. The quick rhythmic brush-strokes and the sketch like quality of the paint surface suggest that the portrait was probably painted in one sitting. However, small alterations such as the deepening of a shadow could be applied at a later date.

The darkest colour areas of blue and blue green are applied first, in short brushstrokes, side by side. Successive overlapping strokes of yellows, pale oranges and reds are then added – never mixed or completely covering the other. Colours which are not applied in their pure form are mixed on the palette and then brushed onto the paint surface. As the colours are not thoroughly mixed on the palette, the separate streaks of different colours can be seen within a single brushstroke. This is quite apparent in the ochre coloured build-ing to the left of the sitter.

The freshness and luminosity of the colour is one of the most striking aspects of the painting.

Seventy-six years later, that same luminosity is still visible and the paint surface remains unmarred by either drying or age crackle. The explanation is to be found in the palette and paint technique of Cézanne's later period. In contrast to the thick, darkly coloured paint surface of his early work, the later paintings are comprised of thin paint layers and do not incorporate complex layers of underpaint and overpaint. In the skilled hand of an artist, who understands the drying problem of lean and rich paint layers, complex paint layers can be successfully constructed. But in the nineteenth century this understanding was not always present and, as a result, many paintings suffered from disfiguring drying crackle and areas of sunken or matt paint. Cézanne's painting methods, as well as those of many of the Impressionists, eliminated this particular hazard. Cézanne's

Paul Cézanne,
'Montagne Sainte Victoire' 1905-6

Paul Cézanne,
'The Gardener'
c.1906

palette was lighter in the sense that it did not include the darker colours of the umbers, siennas and blacks. The one common characteristic of these pigments is the amount of of oil which is required during the grinding and manufacture of the paint. If during the painting process, the quality of oil in these paints is substantially altered, they will eventually crack or darken. By restricting his palette to lighter colours Cézanne, knowingly or unknowingly, lessened the probability of encountering these problems.

As the painting is unvarnished, its surface is particularly vulnerable to dirt and other particulate matter. A varnish layer would certainly protect the paint layer but it would also alter the appearance of the painting by lowering the tone of the colours. Therefore, the alternative is to glaze the frame thus preserving the luminosity and freshness of the paint surface. It is this characteristic combined with Cézanne's extraordinary colour sense which creates this delicate and sensitive portrait of Vallier. Some art historians have suggested that Cézanne was actually attempting to portray himself in these portraits of Vallier. If this is indeed true, then these final portraits are as poignant as they are beautiful.

[1] Letter from Marie Cézanne to Paul Cézanne, 20 October, 1906
[2] 'Cézanne, The Late Work' New York, 1977, The Museum of Modern Art, catalogue, p.95

HAROLD GILMAN 1876-1919 'Canal Bridge, Flekkefjord' 1913

Oil on Canvas 45.7 × 61 (18 × 24)

Harold Gilman trained at the Slade School of Art and became a prominent member of several groups of artists formed in London at the beginning of the twentieth century. He developed his individual approach to painting slowly, absorbing many influences in the process from his English contemporaries and leading European artists of the time, notably the Post-Impressionists. The style he evolved was an attempt to combine a realist approach in the description of everyday scenes with the use of clear and vibrant colour schemes. By 1913 he had evolved a precise way of working to produce the clarity of image he desired. He would make annotated black and white drawings from life until the scheme for the painting was complete, when the design was transferred precisely onto a canvas. The act of painting was then largely the realisation of the carefully preconceived plan transposing the scene into a composition of evenly related colour patches with clear tone and hue values.

The Tate Gallery collection contains two paintings by Gilman from c.1913 with their preparatory studies; 'Canal Bridge, Flekkefjord' (T.3684) and its study (T.26) and 'Leeds Market' (T.4273) and its study (T.143). The study for 'Canal Bridge, Flekkefjord' was made on his travels in Scandinavia during 1912-13. It is an extensively annotated sketch of the bridge in Norway drawn in black ink with a pen on handmade, white, laid paper. Along the top and left of the drawing the uneven decal edges of the original sheet of paper remain. The right and bottom edges have been

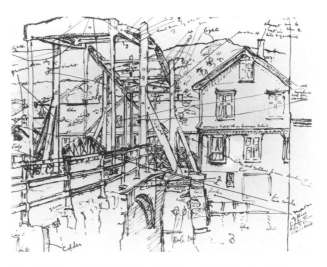

Harold Gilman, Study for 'Canal Bridge, Flekkefjord' c.1913

torn to produce the required size of paper. Gilman drew the scene swiftly and confidently then added extensive notes in ink and pencil to record colour values, his prime interest, and explain some of the forms. Many of these notes are words, such as the record of colours on the side of the bridge – 'blue'; 'cold'; 'pale red'. Comparing the sketch to the painting, it can be seen that these colour notes have been faithfully followed in the painting of the picture. Other notes are in the form of single letters – 'a', 'b' or 'c' and numbers – '1' through '5' which also relate to ranges of tone and hue values. They are particularly profuse on the complex structure of the bridge.

This sketch is probably not the final study from

which the painting was made as the composition is different. In the painting the bridge is more centrally placed, losing features in the sketch to the right and bottom while adding to the left side and top. The study for 'Leeds Market' is an example of a drawing from which Gilman made his paintings directly. The drawing's composition is identical to the painting's in most respects, including the location of the signature, except for the arrangement of the foreground figures. Like the sketch for 'Canal Bridge, Flekkefjord' it is a little less than half the size of the painting and mainly done in pen and ink on paper with superimposed notes. However, it also has a numbered grid drawn over it in red ink which corresponds to the squaring up of the canvas. On the back are some scribbled questions, concerning the complex architectural structures of Leeds Market, with answers showing that

Gilman returned to the scene to clarify his information.

Structurally and stylistically 'Canal Bridge, Flekkefjord' is very similar to 'Leeds Market' which makes it probable that it was painted in England after Gilman's return from Scandinavia in 1913. However, it is possible that it was painted in Norway. Small pin holes in each corner with surrounding circular depressions made in still soft

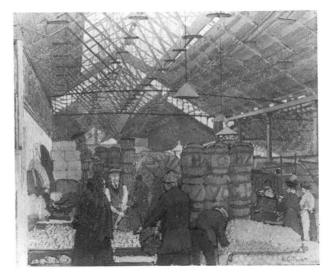

Harold Gilman, 'Leeds Market' c. 1913

Harold Gilman, Study for 'Leeds Market' c. 1913

paint, suggest the use of canvas separators; short wood dowels with a pin at each end, used to hold undried paintings (placed face to face), apart during transport. These holes are present in many of his Scandinavian paintings: such as 'The Verandah, Sweden' (1912) and 'The Mountain Bridge' (Norway, 1913). Gilman's failure to date and title

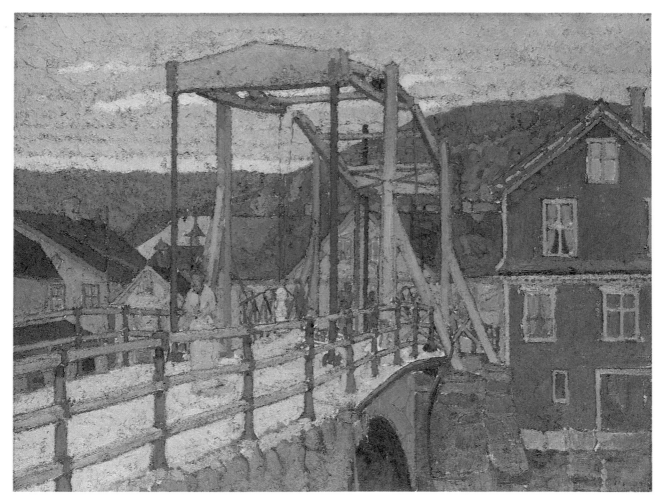

Harold Gilman,
'Canal Bridge, Flekkefjord'
*c.*1913

many of his works leads to problems in arriving at an accurate chronology of their production.

The canvas of 'Canal Bridge, Flekkefjord' is a close, plain weave linen with a white priming applied by an artists' colourman. An illegible stamp on the canvas back, with a handwritten number inserted, probably refers to the batch of prepared canvas from which the piece was cut. Unusually for a commercially primed canvas, it was not sized sufficiently to prevent some ground penetrating to the reverse. The ground is similarly visible on the back of 'Leeds Market'. Like some of the oil paint, the white ground has a distinct yellow, darkening around the edges where covered by the frame. Linseed oil tends to yellow in the dark which visually indicates its use in this ground. The primed canvas was stretched onto a pine stretcher with keyed, expansion, corner joints and attached with fairly widely spaced coated steel tacks.

With the concept of his picture fully worked out, Gilman proceeded conscientiously to produce the completed painting. First, the canvas was 'squared up' with a grid of lightly drawn lines to assist in transposing the design from a preparatory study. On the canvas of 'Canal Bridge, Flekkefjord' the lines are one inch apart being marked off around the edges in ink. The freely drawn outlines of the design were completed with mauve oil paint before painting in the shapes began. This was done with equal certainty of purpose, each stroke of the heavily loaded brush remaining distinct. The oil paint was applied thickly with little addition of thinners or painting medium, retaining the brushmarking and spikey impastos formed as the brush was drawn sharply away from the canvas at right angles. Continuity of paint application was maintained throughout with little change in handling between areas representing sky, landscape, water or buildings. In large areas, such as the sky,

there are no gaps between the abutted brush strokes arranged in horizontal rows but in smaller shapes the paint often does not cover the whole shape, leaving drawing and some ground clearly visible. The final shapes of colour were determined by the application of the paint rather than the initial drawing which is seldom reinstated if covered during painting. Gilman was intent on getting his colour values and application as he wanted it at the first try. Where he has made corrections he has not modified the existing paint with scumbles or glazes but has overpainted it with an obliterating application of the required colour retaining the freshness of the work. This is mainly done wet paint in wet, as in the sky, and only occasionally is already surface dry paint overpainted, as with the shadow of the bridge falling across the side of the house on the right.

The colour mixtures used by Gilman are all opaque, most containing some white. No black is used, Gilman having developed an impressionist's abhorence of its use in painting. Pure white, greys and dull colours mixed from earth pigments are also avoided. The vibrancy of his bright colours and tints is heightened by the juxtaposition of near complementaries, such as the mauve and violet tints of the bridge against the lime green of the building behind, and the many small patches of neutral white ground left visible between shapes. Although Gilman uses unmodulated areas of bright hue to represent the local colours of many features such as the viridian railing posts, he retains careful control over their tonal values which combine with the natural perspective of the drawing to give a fairly realistic description of space.

A sense of movement through the space and scale is provided by the figures on the bridge, not present in the drawing. They are as simply painted as the topographical details and gave Gilman, as

many other painters, the opportunity to introduce small patches of colour contrasting with their surroundings.

'Canal Bridge, Flekkefjord' is easily readable as a conventional depiction of an existing scene, but the strong pattern of the design, decorative colour and emphasis given to the physical presence of the paint by its opacity and vitality of application, continually returns the viewer's attention to the real surface of the painting. Appreciation of the artist's craft is invited as well as interest in the view depicted. The study for the painting, although made by Gilman purely as a working drawing, has intrinsic qualities not transferred to the painting. A feeling of his response to place comes through this unselfconscious drawing and the accretion of working notes over it.

SOURCE
M. Chamot, D. Farr, M. Butlin, *The Modern British Paintings, Drawing and Sculpture* 2 Vols, Tate Gallery, London 1964 Vol. I p.234

PABLO PICASSO 1881-1973 'The Three Dancers' 1925

Oil on Canvas 215.2 × 142.2 (84¾ × 56)

Picasso began painting the canvas in Paris during the early spring of 1925. In March and April he stayed for some time in Monte Carlo, finishing the work on his return. It was reproduced in 'La Révolution Surréaliste' published on the 15 July 1925. During this time the picture underwent several changes, the most dramatic being catalyzed by the death of his old friend, Ramon Pichot, on the 1 March. Picasso worked out these alterations directly on the canvas where they remain embedded in the painting's structure.

'The Three Dancers' remained in Picasso's personal collection for the next forty years until he sold it to the Tate Gallery in 1965 through Sir Roland Penrose. It was not until then that Picasso signed the painting. By that time it had come to be regarded as a major innovation in his work, introducing an unprecedented expressionism in his distortion of human form and use of colour. A full discussion of the stylistic evolution and interpretation of the iconography is to be found in Ronald Alley's catalogue entry in 'Catalogue of the Tate Gallery's Collection of Modern Art other than by British Artists'.

There are no surviving studies for 'The Three Dancers' although the theme of the dance occurs in many earlier works and the drawings of the Ballets Russes made in Monte Carlo during April of 1925. These almost classical drawings from life are very different to the painting. Similar in composition to it is a small bacchanalian oil sketch, 'The Dance' painted in 1923, which shows three nude dancers linked in almost identical poses to

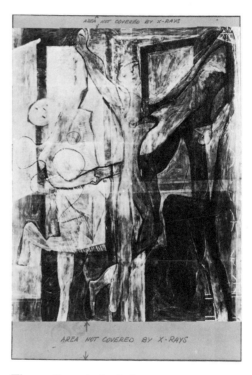

The x-radiographs (excluding top and bottom edges)

those of 'The Three Dancers'. Examination of 'The Three Dancers' and x-radiographs shows that in its earlier stages it was much more closely related to 'The Dance', in concept, the dancers being drawn with sensuous lines giving a fullness to their forms that were later eradicated. This is most clearly revealed in the x-radiographs of the dancer on the right, who was originally drawn as a

voluptuous female figure, then reduced to the present series of flat planes linking the figures and foreground to the background of the shallow picture space.

Picasso, a master of painting techniques, chose in this case to use traditional materials in the most straightforward way imaginable. The image is simply and powerfully presented without recourse to unusual materials or complex procedures.

His support is a fine, plain weave linen canvas, sized and primed with a thin layer of a cool, mid-tone, grey ground. This was probably prepared by an artists' colourman, although there are no identifying stencils or stamps. The primed canvas was stretched onto a basic, pine strainer and attached with steel tacks, grouped in threes. Each group of tacks corresponded to the jaw width of the canvas pliers used to pull the canvas taut during stretching. The strainer had nailed mortise and tenon corner joints with mitred inner edges which allowed the bevel on the inner faces of the strainer pieces to be machine cut. An attempt was made to improve the rigidity of the strainer by fitting a cruciform brace of two crossed, half lapped timbers with screwed joints. However, the strainer was not stable and was replaced in 1978 to allow the painting to travel to the Picasso Retrospective at the Museum of Modern Art, New York, U.S.A.

The paints used for 'The Three Dancers' have the characteristics of oil colours with the possible addition of some painting medium. Research into Picasso's materials, by the Laboratoire de Recherche des Musées de France, has shown that for oil painting he used artists' colours made with traditional pigments bound in drying oils such as linseed and poppyseed oils. It is also known that Picasso used paints formulated for other uses such as 'Ripolin' marine paints and where he required a matt finish an oil/size emulsion paint (N.B. This

may be the type of lean white paint used in 'Goats Skull, Bottle and Candle' 1952, Cat. No. T.145). Where he required a paint of extra brilliance, Picasso added media containing natural resins. Analysis of white paint from 'The Three Dancers' has been made by Dr John Mills and Dr Ashok Roy of the National Gallery's Scientific Department. Their analysis showed the paint to be basic lead carbonate in a medium of simple drying oil, most probably poppyseed oil. This is a standard formulation for a commercially produced, artists' white lead oil paint.

The uniqueness of 'The Three Dancers' is thus not in the materials but in the way in which they are handled. There is no visible evidence of initial drawing. Linear work is visible at all levels, continuous with the rest of the painting. It is not just used to delineate shapes but is used extensively across broader shapes to modify them, and as independent forms. As well as being thickly drawn with a brush, the lines are incised into partially dry paint or squeezed from the paint tube.

The paint is applied in increasingly thick layers intended to cover completely those below. Underlying films were often sufficiently dried to retain their conformation when overpainted and in some areas, such as the top left quarter, a layer of white paint was applied to obliterate earlier work and provide a light reflective base to continue work over. Extensive reworking during a period of several months built up a structure of many superimposed layers. Picasso's development of the sculptural presence of the paint accompanied his contraction of the picture space, thrusting the increasingly distorted figures to the front of the picture plane. Colour and shapes became less representations of natural form than complex symbols of emotional states.

The intricate surface of the encrusted paint is

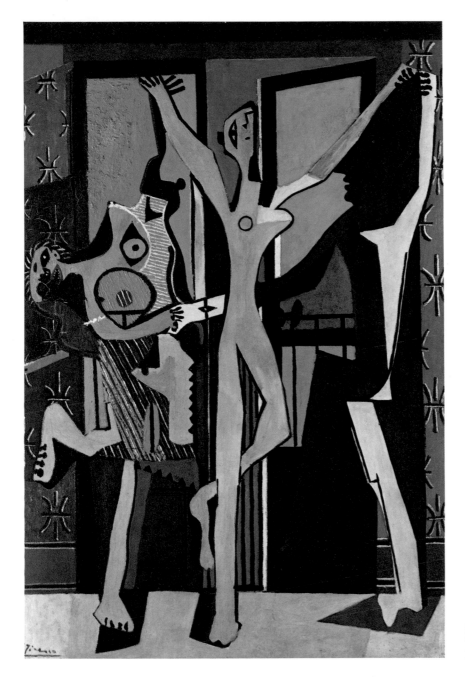

Pablo Picasso,
'The Three Dancers'
1925

most clearly seen in raking light when underlying forms emerge and the vigorous brushmarking and clotted impastos are dramatically apparent. All the paint retains brushmarking although it is often softened by the flow of the thick paint, rich in medium, before it gelled. Small, stringy worms of splashed paint on the picture surface indicate that it had the consistency of a fluid paste when applied. A more fluid paint, like household gloss, would have spread out losing most traces of brushwork while a stiffer paste would have retained sharper brushmarks.

The surface conformation and appearance of the painting was further complicated by the con-

traction of the thick paint as it consolidated over the years. The contracting paint exerted sufficient force in dense areas to distort the canvas from its flat, stretched plane. This is not visible from the front but the wrinkles and cracks in the paint are. These contraction cracks occur in many areas, most dramatically in that of the head of the dancer on the left. The cracks split open as the contracting paint slipped over underlying layers to reveal the paint below. Cracks in the black of the head partially penetrated the pink below and stopped at the layer of white applied to isolate earlier work. Developing cracks followed the course of least resistance in the paint films which occasionally coincided with the contours of underlying forms such as the overpainted right eye. Picasso, in dis-

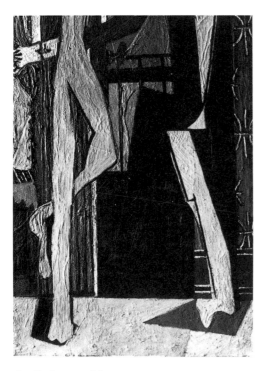

detail – bottom right

detail – left

cussion with Penrose, commented on these cracks, 'The paint is solid enough and will not flake off. Some people might want to touch them out but I think they add to the painting. On the face you see how they reveal the eye that was painted underneath.'

A less obvious change has been in the surface reflection. Differences in surface gloss were used intentionally by Picasso and probably also occurred accidentally; intense colours are generally glossier than the pale tints or sombre shades. Initially the degree of gloss was determined by the type of medium, its ratio to the pigment and its drying. Picasso may well have used paints made richer in medium as the layers built up to counteract the 'sinking' of the medium into underlying films. With the action of light, moisture and airborne pollutants the medium of some of the paints has begun to degrade causing a slight breakdown of the paint surface, increasing light scatter (matteness), visually most obvious in the darks.

Several of the paint films are now poorly bound, such as the greens, and are readily soluble in water and organic solvents. This means that a protective varnish film cannot be applied because where it covered or penetrated the lean paint it would not be safely removable in the future. A varnish would also alter the relative gloss and colour values of the painting. The apparent robustness of the execution belies the delicate condition of the surface.

Picasso's bold choice and organization of colours complements his forthright handling of the paint. Except in the residual flesh tints of the figures, each shape or line is laid on in one unmodulated colour. Larger shapes are sometimes overlaid with smaller shapes, patterns or drawing but each application is distinct in form and colour. The colours are used unmodified or in simple mixtures; their effectiveness being achieved by the juxtaposition of vibrant hues and contrasting tones in an energetic composition maintaining a human sense of scale with its life size figures.

The clarity of line, shape and colour create an imposing formal structure conveying Picasso's intentions directly to the viewer. The sense of compulsive agitation is relieved only by the quiet curves of the dead Pichot's silhouette against the sky in the right hand window. Picasso said of the painting 'I have always felt that it should be called "The Death of Pichot" rather than "The Three Dancers"', reflecting the deep personal associations it had for him. As demonstrated in the various states of some of his etchings, Picasso had a formidable capacity for totally altering the appearance and meaning of an image while retaining the skeleton of its descriptive subject matter. 'The Three Dancers' embodies such a metamorphosis in feeling and form the process of which remains cocooned within the structure of the painting.

SOURCES

Ronald Alley, *Picasso: The Three Dancers,* The 48th Charlton Lecture, University of Newcastle Upon Tyne, 1967

Ronald Alley, *Catalogue of the Tate Gallery's Collection of Modern Art other than by British Artists,* Tate Gallery and Sotheby Parke Bennet, London 1981 catalogue entry T.729, Picasso, 'The Three Dancers' p.598

Suzy Delbourgo, 'Etude de la Matiere Picturale de Pablo Picasso', *Comite pour la conservation de l'ICOM 6eme Reunion triennale, Ottawa 1981 Groupe de travail:* Peintures du 20eme siecle 4 vols 1981 81/6/2

MAXWELL ARMFIELD 1881-1972

'This England – Portrait of an Owner' 1943

Tempera 39.3 × 39.7 (15½ × 15⅝)

This painting is in tempera, a term used to describe a binder made from egg, although the term can be applied in a wider sense to describe a variety of water-based media. The egg yolk technique is thought to have been brought to Italy by Byzantine icon painters, who had inherited it from the Egyptians. The method, as described by Cennini in his 'Craftsman's Handbook' written in the fifteenth century, was eventually eclipsed by improvements in oil painting which spread from northern Europe. It is hard to know how much of an egg tempera tradition was ever established in England because few medieval pictures have survived, but it was not in common use when William Blake was looking for alternatives to oil paint. Blake experimented with glue size as a medium. His followers, Samuel Palmer (see Palmer page 39) and George Richmond, also used glue or gum in their tempera works. Blake's acquisition of a copy of Cennini in 1822 did not cause him to try egg. The book was translated into English in 1844 but failed to interest painters at the time.

The use of egg tempera was probably first revived either by Spencer Stanhope or Walter Crane in the early 1870s after visits to Italy, where the method had never quite died out. Joseph Southall also became enthusiastic about tempera after seeing early Italian paintings, and by the end of the century there were a number of people working in the technique. The first exclusively tempera exhibition was held in 1901 at Leighton House.

At the turn of the century Maxwell Armfield went to Birmingham Art School, which was then a centre of the Arts & Crafts movement. He was taught by Arthur Gaskin and Henry Payne, and came to know Southall, from whom he learned much of his tempera technique. As well as painting, Armfield wrote prolifically and in 1930 published his useful *Manual of Tempera Painting*. This describes the straightforward egg method, whereby a careful monochrome underdrawing is covered with semi-transparent layers of colour. The paints are made by grinding pigment with egg yolk and water, with white added to adjust the tone. Variations include Stanhope's method of using larger amounts of white mixed with undiluted yolk for a thicker opaque paint, and Southall's use of glazes with hardly any white. Armfield himself preferred a mixed technique involving the addition of an equal quantity of linseed oil and copal varnish to the yolk emulsion. In what he called his Flemish method, he used a neutral coloured ground, on which he modelled the entire composition in pale colours using egg. Once this was dry he applied coloured glazes in oil and varnish using little or no egg. He felt, with some justification, that this method gave much better depth.

The classic support for tempera is the gessoed wood panel. This involves many thin coats of whiting in a size solution. Both faces of the wood are covered to reduce the risk of warping. The surface achieved is smooth, hard and takes the

paint well. Additives such as marble dust can give more 'tooth' if it is wanted. Armfield used to make his own panels, as described in the manual, and inherited some from Southall together with his pigments. However, he was always experimenting with new materials and techniques and was apt to use thin inadequate plywood, sometimes covered with paper or silk instead of gesso. After the 1939-45 war he settled on hardboard, often simply primed with mushroom coloured Walpamur paint, sealed with shellac. Other materials used include Whatman laminated paper board and pulp boards. The use of an unsupported sheet of paper for the 'Portrait of an Owner' is unusual. It is a well sized heavy weight paper, probably Whatman Hot Pressed. Egg medium has possibly been applied to the paper as recommended in the Manual, to avoid any risk of the tempera peeling away from an absorbent surface. Unfortunately the difference in expansion between paint and paper in response to relative humidity changes means that the work has a tendency to cockle.

The picture is a view of the industrial society that Armfield hated, and satirises a small industrialist. Based on a drawing of his father, the pencil drawing for the design is clearly visible. The tempera has been applied thinly, with little white, which allows the paper to reflect through in the manner of a watercolour. The flesh colour has been built up over terre verte underpainting in the usual tempera fashion. The egg medium sets quickly, so that little fusion can be made between brush strokes. Armfield made use of this to paint different or complementary colours, either stippled in adjacent dots, or overlaid in thin washes. He felt that using colours in this way, instead of mixing them, could maintain the purity of each and give variety and vitality to the surface. He had an impressive collection of pigments which he liked to use pure for maximum effect, for example the purple madder of the roses in the 'Portrait of an Owner'.

One of the endearing features of tempera is that in mixing the pigments with the medium, it is not easy to achieve absolute homogeneity, especially when – as can happen – the artist dips a brush loaded with egg straight in the dry pigment and only disperses it briefly on the palette before use. Some of the particles stay in clumps, which can add to the interest of the paint, though obviously there is a danger that they may be insufficiently bound.

The translucency of tempera obviously means that mistakes or alterations are difficult to obliterate but small areas of paint can easily be removed with a damp cloth since the egg takes a long time to harden once it has dried. Impasto is ruled out because the water based paint would contract too much as it dried and therefore crack. A wide variety of effects are possible however, such as scraping, spongeing and spattering. Tempera can also be sprayed to cover larger areas since traditional hatching with a brush is laborious. A slight reduction in the amount of medium will give a matt surface.

Just as in watercolour, glycerine is sometimes added as a humectant to prevent the paint film becoming too brittle. Unlike oil paint, egg tempera does not yellow and darken with age, and paper is not discoloured or embrittled by the medium as it is with oil paint. It is wise not to use pigments (such as lead white) that are vulnerable to sulphur (the egg contains sulphur) but a reaction is unlikely unless the picture is kept in a damp place. Fading is possible if the picture is only thinly painted, so the light level for exhibition needs to be kept low as for watercolours.

Armfield often varnished his finished works

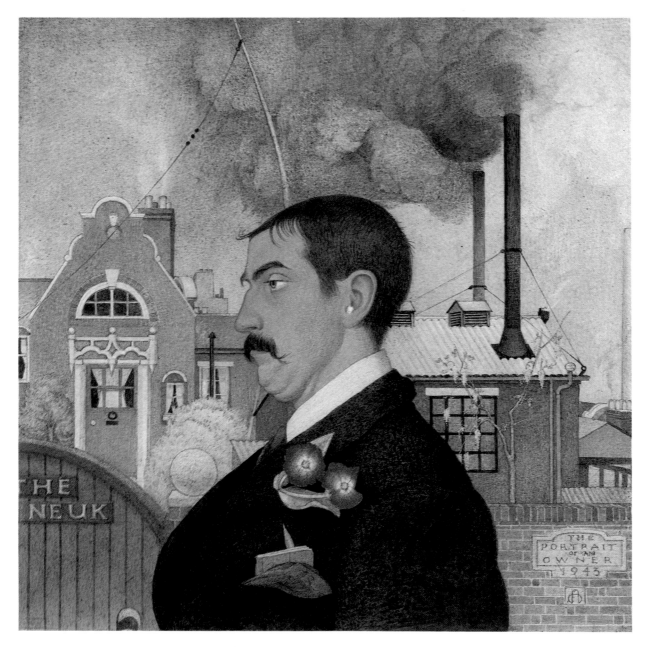

Maxwell Armfield, 'This England – Portrait of an Owner' 1943

using natural resins, These he sometimes tinted to give a warm effect. The 'Portrait of an Owner' appears to have been given an uneven coating of egg medium which is now totally insoluble in water. In a few localised areas it shows signs of flaking off. The brush used to apply the tempera varnish has shed hairs which are embedded in the surface of the picture.

Armfield's 'picture record notes' detail the technique and materials used for each of his paintings but sadly are brief for the 'Portrait of an Owner'; being simply 'Theme of Capricorn and Colour Pentatonic on 1'. He became increasingly interested in Astrology and Buddhism after his wife's death in 1940. Using the pseudonyms Darval and Moxford he wrote three books about his colour theories which Pentagon Press published in the 1940s. It is not clear why he chose the capricorn theme for the picture (note the horn) but according to his beliefs green and magenta are both linked to this sign. Both colours are prominent in the picture.

What is not in the Notes is his usual reference to the composition. Armfield was an enthusiastic believer in J. Hambidge's theory of Dynamic Symmetry, which claimed to be a rediscovery of the lost system of proportion used by the Egyptians and Greeks. It is concerned with ratios of area rather than lengths of line. 'Individual parts being planned on a system of proportion permeating the whole composition' and the visual basis is 'the proportional rectangular or curved spiral'. Hints of rectangular spiral construction may be seen in the background of 'The Portrait of an Owner'.

Tempera painting has tended to attract eccentric artists, and the painter of this excellently odd picture was no exception.

SOURCES

Max Armfield, *A Manual of Tempera Painting,* Allen & Unwin, London, 1930
Illustrated Catalogue of Acquisitions 1974-6 Tate Gallery, London, 1976

GRAHAM SUTHERLAND 1903-1980 'Somerset Maugham' 1949

Oil on Canvas, 137 × 63.5 (54 × 25)

The portrait of Somerset Maugham, painted by Graham Sutherland in 1949, was the artist's first attempt at portraiture during his established career, as an etcher (until about 1930) and then as a visionary painter of landscape. The attempt proved to be highly successful.

It was a chance observation by the artist that lead to the commissioning of the portrait. Having met Somerset Maugham the year before at St-Jean-Cap-Ferrat, Sutherland had remarked that, if ever he did portraits, Maugham would be the kind of person he would like to paint. When Maugham came to hear of this, he wrote to the artist to commission a portrait. Sutherland refused at first but was persuaded by Maugham to undertake the task, on the basis that it was to be an experiment only.

Sutherland approached the work with understandable caution. Fortunately he was able to utilize the technical drawing experience that he had gained from his days as an apprentice engineer in the Midland Railway works in 1918 and his etching experience at Goldsmith's College of Art, London 1921-6. Other paintings by the artist from the same period follow his more recognisable, freer style ('Crucifixion' 1946; 'Origins of the Land' 1950-1) being unrestrained by the disciplines of portraiture.

Maugham provided the artist with about ten sittings of approximately an hour each, beginning in February 1949. During these sessions, Sutherland concentrated solely on the drawing of his subject and he became fascinated 'trying to pin down the essence of a person'. He used tracing paper for the working drawing, which he copied twice, in case the original suffered during the tracing. Apart from these, the only other drawings undertaken by the artist were details of Maugham's facial features and clothes, made while the work was in progress. Sutherland then transcribed his drawing onto the thin, white priming of the commercially prepared canvas. He did

Graham Sutherland, Study of the Head for the Portrait of W. Somerset Maugham The Fitzwilliam Museum, Cambridge

not appear to be too concerned with preparing his own canvas and was content with purchasing a commercially produced support. The canvas for the portrait does not have a maker's stamp on the reverse, so we do not know where he purchased it. The existing stretcher is the original one, made up of six pine pieces or 'members'. On the whole it is still in good condition, although rather poorly constructed and is typical of a cheaper shop-bought stretcher.

Faint traces can still be seen through the paint layer where the artist has 'squared-up' his canvas with thin lines of dark paint and intersecting pencil lines to aid the proportioning of the figure onto the canvas from the sketch. Despite the care taken in transferring the drawing onto the canvas, there have been some alterations in the body which might explain the slightly uncomfortable appearance of the torso. Unlike many other paintings by Sutherland, the squaring-up did not become an integral part of the image but was painted over. The artist worked on the portrait from the preparatory drawings and not in the presence of the sitter. He found the proximity of the sitter distracting and, became confused if he was in front of the subject for too long, being keen not to obliterate his original concept.

The paint film itself has the appearance of commercially prepared artist's oil colour rather than a studio-prepared material. The white priming layer of the canvas has been used by the artist in his handling of colour, to achieve some of his colour tones, especially in the face and head. It is still visible where the paint has been applied very sparingly, for example in the area of the neck and hands. This white, reflective, under-layer helps to give the top paint film a more luminous and vivid appearance by utilizing the transparency of the paint film. Where the paint of the head has been

thinly applied, it can be seen that there have been very few, if any, alterations in its design on the canvas. This tight construction would be a result of the faithful following by the artist of the preparatory sketches and his unwillingness to work too freely in an unfamiliar field. There are also some areas of thicker paint and impasto in the construction of the highlights of the head and face, especially around the eye that is closer to the viewer, and the sitter's prominent chin, upper lip, nose, cheekbone and brow.

After the area of the head had been established, it can be seen that the background has been blocked in around it with thick orange paint. Noel Barber describes it as 'the Buddhist orange of the Somerset Maugham, with features of a Siamese abbot'. This background paint is unthinned and very rich, it moves through various warm tones of orange almost completely filling the space with well defined brushstrokes, creating a hot, tropical atmosphere. The background has been treated far more freely than the figure, to convey mood rather than detail – even a loose design in the paint layer, faintly visible in the top right-hand corner, has not been developed.

Maugham's oriental connections are reflected in the artist's choice of setting and pose for the author. The sketchy plant fronds which just hang down into the painting and the bamboo seat both hint at the location. The folded hands, aloof expression and slightly yellow pallor (Sutherland described Maugham's skin as being like 'parchment'), make Maugham somewhat inscrutable. He saw the pose as being 'uniquely significant for Maugham'.

Some of the areas of paint, especially the red scarf, the sock and the shadows beneath the seat are noticeably leaner than the rest of the painting, exhibiting a dry and matt surface. The outlines of

Graham Sutherland,
'Somerset Maugham'
1949

both the figure and the plant fronds have been reinforced in some places by thin dark lines. For the leaves, Sutherland appears to have used a waxy-type crayon which he has applied quickly and loosely. Around the figure he has taken more care, with black paint drawn thinly and deliberately in those areas where the form needed definition. Although, on the whole, the painting is not highly finished, the head has a much higher degree of definition than the rest of the image. This is an effective technique for focusing the viewer's attention onto the most important part of the painting – the face.

The portrait was completed early in June 1949. Maugham was extremely pleased with the result and called it 'magnificent – there is no doubt that Graham has painted me in a mood and with an expression I sometimes have, even without being aware of it.' Later portraits by Sutherland become less linear and 'caricaturish' as he became more sure of his abilities to transport features and personalities onto canvas using the painting technique that he had previously developed – taking a new approach to appearances just as he had done with his studies of nature.

The painting was presented by Somerset Maugham to his daughter, Lady Joan Hope, who gave it to the Tate Gallery in 1951. Maugham wanted to give the painting to the Tate Gallery but he felt it would be wrong to present it himself so he asked his daughter to do it for him.

N.B. The small crack in the paint film (approximately 250mm) just above the sitter's right shoulder was caused by the impact of a French customs stamp applied to the back of the canvas sometime in the past.

SOURCES

Paintings and Drawings by Graham Sutherland, London, 1953, Arts Council and Tate Gallery Catalogue
Time Magazine, 13 June 1949 p.51
Noel Barber, *Conversations with Painter,* Collins, London, 1964 pp.44, 51-53

HENRI MATISSE 1869-1954 'The Snail' 1953

Gouache on Paper, 285 × 287 (112¼ × 113)

At the age of 72 Matisse underwent surgery for a serious abdominal complaint which left him very weak and confined to his bed and a wheelchair. Two years later in 1943 he began some work with a method he had first used in the early thirties for the preliminary studies for La Danse. Large sheets of white paper would be colour washed and left to dry. Shapes would be cut out from the coloured sheets and arranged on a white background. When the work was complete the pieces would be stuck in place.

These 'cut-outs' by Matisse should not be regarded as collage. He felt that this method allowed him to work directly in colour without the intermediary stages of drawing a shape and filling it in. 'Cutting straight into colour reminds me of the direct cut of a sculptor' (Découper à vif dans la couleur me rappelle la taille directe des sculpteurs).

'The Snail' was completed in 1953, one year before Matisse died, and by that time the basic techniques and methods of working were more or less routine. His assistants would brush sheets of paper with Linel gouache. These were left to dry and stored until needed. Matisse had first used Linel gouache when he was working on the paper cut-outs which were to illustrate his book *Jazz,* published by Tériade in 1947. It is notoriously difficult to reproduce in print the subtle nuances found in watercolour. Matisse discovered that the Linel colour range could be perfectly matched with the printing inks. He continued to use them for all his cut-outs.

When the coloured papers were ready, a large sheet of white paper would be pinned to the studio wall. Many of the later cut-outs are large in scale. When, much earlier, Matisse was talking about drawing from a model, he described himself as looking very closely, 'his face a few feet away, their knees almost touching.' ("Je dessine tout près du modèle – en lui même – les yeux à moins d'un mètre du modèle et genoux pouvant toucher le genou" – Louis Aragon, *Henri Matisse Roman* 1974.) Towards the end of his life, confined to a wheelchair, he was directing his assistants, and working from a distance. Although the single elements in the works are usually of moderate size, the end results are often huge and envelop the spectator.

Matisse would cut and tear the shapes from the coloured papers which were then pinned in position by his assistants. This stage in the work could take days or even months. The corners of several of the pieces in 'The Snail' have clusters of small pin holes where they were moved around and re-pinned. When the work was finally completed very careful tracings would be taken of the positions of the pieces and the whole work would be sent to Paris to be properly mounted. In the case of 'The Snail' a linen canvas was stretched over a wooden stretcher and lined with three vertical strips of brown Kraft paper. This paper is visible down the left side of the work. The intermediary layer of Kraft paper meant that there was less likelihood of distortions in the surface plane caused by expansion and contraction of the canvas

and would also minimise the possibility of the texture of the canvas showing through onto the front of the work. Frequently, by the time the composition was completed, the original white backing paper was damaged or discoloured and a new piece would be used for the final mounting. In this instance two vertical strips of white paper, overlapping down the middle, have been used as a background. They have also been given a thin coat of white paint, possibly because the white shapes play such an important part in the composition. The colour of the original paper can be seen down the right edge. It is very probable that this paper has yellowed with age and it is perhaps fortunate that the white paint has preserved the tonal background of the original work.

The tracing was laid over the backing and the coloured pieces were positioned on the white paper. Their positions were indicated with faint pencil lines. These lines are just discernible around the torn shapes. Finally, the pieces were glued and stuck firmly into place.

Matisse was working in the South of France just after the war and had to use papers which were easily available. For this work the gouache has been brushed onto a Canson paper which is clearly watermarked 'CANSON & MONTGOLFIER – VIDALON – LES – ANNONAY – LAVIS B – ANCHes – MANUFres' on several pieces. A good example can be seen on the green shape in the bottom right corner. The surface characteristics of uncoated papers generally fall into three broad classifications. These are H.P., or hot pressed, which means that the surface is smooth, NOT, or not hot pressed, which is a matt or medium surface, and ROUGH, which is a comparative term and often means that the paper has been given an artificial texture. The paper in this case is NOT and the slight tooth of the surface would take and hold the paint very well. Gouache has a greater opacity than watercolour and it has been applied in definite lines across the paper. These lines have been used to give direction and movement to the composition.

In June 1954 Matisse wrote to Pierre Berès expressing concern over the level of lighting in the room where one of his works was hung – 'Even if gouache does not have the fragility of watercolour, nevertheless it is not, you must understand, like a piece of ceramic and unaffected by excessive light' (Si la gouache n'a pas la fragilité de l'aquarelle, elle n'est pourtant pas, vous le savez, comme la céramique insensible à la lumière en excès).

Matisse was aware of the fading of colours by light. Nowadays of course we are also aware of the damage done to the paper support by excessive light levels. The wish for permanence in his work was probably another reaon why Matisse chose to use Linel gouache, which was claimed to be lightfast. In 1962 small samples of some of the paints found in 'The Snail' were analysed by the Scientific Department in the National Gallery. In her reply, Joyce Plesters wrote 'The pigments identified are all known to be relatively stable to light and atmosphere, some of them among the most "permanent" of the artist's palette'.

During a routine examination in 1978 the edges of the coloured shapes were slightly lifted to examine the paint underneath. No evidence could be seen of a colour change between the exposed and hidden pigments. We can be reasonably sure that the work we see today has the same colour and tonal relationships as those so carefully chosen by Matisse thirty years ago.

'The Snail', for all its apparent simplicity and directness, was made very near the end of a long and active life during which Matisse was constantly working towards new methods of expres-

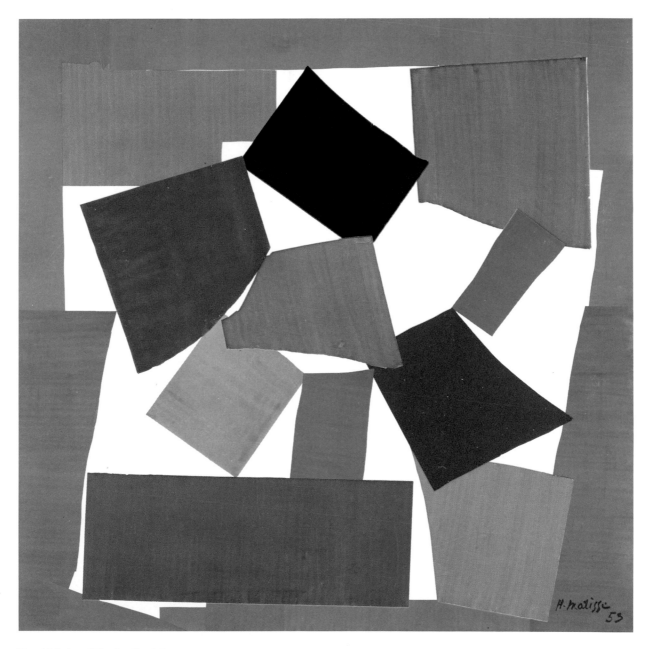

Henri Matisse, 'The Snail' 1953

sion. 'An artist must never be a prisoner of himself, prisoner of style, prisoner of reputation, prisoner of success'. (*Jazz* 1947)

SOURCES

Henri Matisse Paper Cut-outs, Detroit, 1977, Detroit Institute of Arts U.S.A. exhibition catalogue

Ronald Alley, *Catalogue of the Tate Gallery's Collection of Modern Art,* Tate Gallery and Sotheby Parke Bernet, London 1981

Henri Matisse, *Ecrits et propos sur l'art* Ed. Domenique Fourcade, Herman Paris 1972

E.J. Labarre, *Dictionary & Encyclopaedia of paper and papermaking* Second Edition, Swets & Zeitlinger, Amsterdam 1952

MORRIS LOUIS 1912-1962 'Vav' 1960

Acrylic on Canvas, 260.3 × 359.4 (102½ × 141½)

In the middle of the twentieth century one of the great centres for modern art was New York City. It was here that Jackson Pollock, Helen Frankenthaler, Mark Rothko and others were struggling to formulate visually their ideas about expression and abstraction in art. To the south in Baltimore, Maryland, a city of rather provincial tastes, Morris Louis was attempting to express his ideas about abstraction and its future. By nature Louis was a loner but he had the good fortune to be a friend and painting companion of Kenneth Noland, who was as gregarious as Louis was reticent. Noland would journey back and forth to New York and would tell Louis about the current artistic atmosphere in New York, particularly the importance of Pollock's 'all over drip painting' of 1947-50.

In April of 1953 Noland and Louis, in the company of Clement Greenberg, the New York art critic, visited the studio of Helen Frankenthaler in New York. Her painting, 'Mountains and Sea', was to have an enormous effect on Louis in that it introduced him to the visual possibilities of stain painting on canvas. 'We were interested in Pollock,' Noland relates, 'but could gain no lead from him. He was too personal. But Frankenthaler showed us a way – a way to think about and use colour.'[1] It was the way in which colour could be soaked into a canvas and be a part of it rather than a distinct layer. This was to be the germinating seed from which Louis' ideas of colour field or colour configuration painting were to grow and eventually influence succeeding artists' ideas about the relationship of canvas, colour and space.

Frankenthaler had shown Louis the possibilities of colour in stain painting and the newly developed acrylic paints provided the means for expressing these ideas. Louis had used acrylics as early as 1948 but it was not until his visit to Frankenthaler in 1953 that he realised the possibility of using them in a stain technique. Acrylics offered several advantages over the traditional oil based paints. Unlike oil based paints, the acrylics did not contain an acidic component which would eventually deteriorate the unsized canvas fibres. They could be thinned to a consistency which would allow the paint to flow over the canvas surface and yet retain the necessary binding properties of the dried film. The acrylics also dried quickly which would allow the artist to superimpose several successive layers of paint without long intervals for drying.

Louis painted with Magna colours, a trade name for the acrylic based paint manufactured by Bocour Artists' Colours Inc. It was an oil compatible acrylic resin paint which consisted of a methacrylate resin (Rohm and Haas Acryloid F 10 – 40% resin solids in mineral thinner and an aromatic solvent, Amsco F); a thinner which was turpentine; an emulsifying agent (beeswax), and pigment. The consistency of the paint could be adjusted by either adding the resin, F10 Acryloid, which Louis purchased direct from the manufacturer, or the thinner.[2]

In early 1960, Bocour changed the formulation of Magna to provide a more bodied paint which

increased the impasto capabilities and allowed for a firmer brush stroke. Louis discovered that this paint was no longer adaptable to staining and discussed the problem with Leonard Bocour. He formulated a paint medium for Louis (and other painters) which consisted of pigment plus 50% Acryloid F10 and 50% turpentine but did not contain the emulsifier, beeswax[3]. This formulation created a paint which was extremely soft and liquid but had one major disadvantage. Without the emulsifier, the pigment tended to separate from the resin upon standing. To avoid separation, the paint had to be mixed or turned upside down in the can at regular intervals. From a technical point of view it is difficult to say if this formulation may have led to uneven pigment dispersal in the paint and therefore an uneven appearance in the applied paint layer. There may also be some effect on the durability of the dried paint film.

The actual method by which Louis applied the paint is not known because he was reticent about his technique and did not want it to become more important than the visual statement. Nevertheless, an examination of his paintings and a study of the available documented information does provide a clearer understanding of his technique and choice of materials. Cotton duck had become a fairly common support due to its cheapness and its availability in large sizes. Louis appears to have used a standard 120″ high roll but varied the width. As cotton duck was a more absorbent material than linen, it would be the more appropriate material for the stain technique. Its light or off white colour in comparison to the darker colour of linen may have provided an aesthetic reason for its selection (see David Hockney, page 108). The cotton duck canvas may or may not have been sized, but there is no pigmented priming applied.

The quantity and type of size would affect the staining ability or penetration of the paint film into the canvas. It is believed that Louis stopped sizing his canvases after his Veil series of 1960. One can only presume that he wished to increase the penetration of the paint into the canvas fibres.

The canvas was either laid flat on the floor or loosely draped or stapled to a rectangular frame. As Louis' painting studio was not very large (14′ × 12′2″), the rectangular frame was made as large as the room would permit, approximately 12′ × 8′. (These dimensions were determined by measuring the distance between the original staple marks that remain on the canvas[4].) To add rigidity to the large frame, crossmembers or braces were probably added. An examination of the paint surface of the large Veil series indicates that the two crossmembers or braces were spaced at an unequal interval – one in the centre and one right of centre. (As the canvas would have rested on the crossmember, an impression of the crossmember would be visible in the paint film.) Whether the positioning of the crossmembers was a practical decision which led to a pleasing visual appearance in the paint or a deliberate selection with the resulting paint appearance conceived as part of the original intention is difficult to say.

Once on the frame, the canvas could be pleated to make troughs for the following paint. The frame could either rest against the wall or be propped up off the floor. It could be moved to enable the control of the movement of the paint across the canvas. The paint would be poured from either the raised top edge of the canvas, the side, or the centre and would flow downwards, sideways, or back against itself depending upon the movement of the frame. Excess paint would either collect at the bottom edge forming a wider, darker area or would be quickly removed with a sponge to avoid

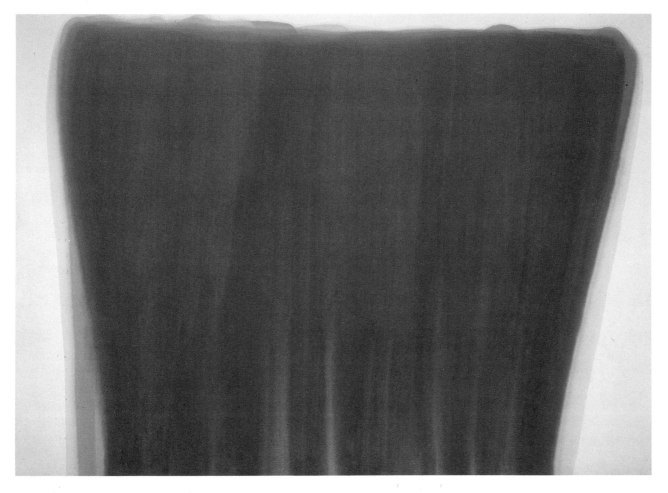

Morris Louis,
'Vav' 1960

this buildup. After applying the paint layers, the drying time was decreased by the use of large fans. Louis would then roll the painting up and move it to a larger room where he could properly view it. If necessary, the painting was then returned to the studio for further work.

The painting, 'Vav' (1960) is an excellent example of the stain technique in its perfected form. Louis poured adjacent plume-shaped washes of pale yellow, orange, and purple down the canvas's surface. This was followed by overall layers of red and orange paint which completely covered the underlying layer except for the small crests of colour along the top and side edges. These layers were probably poured onto the canvas and the flow of the paint was controlled by the manipulation of the stretcher. However, the final layer of darker pigment was probably applied by means of a large swab-like stick or instrument which would have enabled Louis to have greater control of the outline or contour of that paint layer.

The canvas appears to have been pleated along the bottom edge causing the colour to flow to either side of the pleat forming vertical spearlike images. A series of dark or light horizontal bands can be seen in the paint layer. This may have been caused by the crossmembers of the working stretcher although the apparent number of crossmembers, as indicated in the paint layer, is unusual. The other possible explanation is that the marks may have been caused by the rolling of the canvas for storage or transport. As the thinness and granular quality of the unvarnished paint surface is particularly vulnerable, scratches, scuff marks and other types of abrasion easily mar the surface of the paint.

A semi-transparent, varnish-like film can be seen around the edge of the painted image. This is the resin component of the acrylic paint which has been separated from the paint by the capillary action of the canvas fibres. The same effect can be seen at the edge of the orange layer where the paint gradually diminishes in intensity as it is drawn along the canvas fibres.

The painting provides an example of a complex study of colour interaction or colour configuration. But unlike traditional painting, where paint is superimposed over a white or coloured ground, it is the study of the colour value of paint absorbed into a canvas. The colour of a ground affects the layers of paint which are placed over it. Light, striking the painting, penetrates the paint layers and is absorbed or reflected by the ground layer. The reflected light passes back through the paint layer affecting the value of the colour. However, with stain painting, the ground is eliminated and, as a result, the paint colours become uniform in value.

The combination of unstained and stained areas of canvas presents a difficult problem when the painting is stretched. The stained area is stiff and inflexible in comparison to the elasticity of the unstained canvas. The artist Bernard Cohen, who had assisted in the stretching of Louis' striped paintings at Kasmin Gallery in 1963, remembers 'that the canvases had to be stretched very tightly, because the area where the paint had soaked into the fibre had gone quite hard and it was necessary to pull out wrinkles that formed in the material along the edge of the hard paint'.

The examination and study of his major work reveal that Louis fully explored the various possibilities of colour and space, and in conjunction with the stain technique created large scale paintings of colouristic richness. Unfortunately, Morris Louis, unable to recover from the operation to remove his cancerous left lung, died in September

of 1962. Thus his developments and explorations
with the stain painting technique were confined to
a very short period between 1954 and 1962.

[1] James McTruitt, *Art-arid D.C. Touted 'New' Painters,*
Washington Post, 21 December 1961, p.20
[2] *Morris Louis 1912-1962,* Museum of Fine Arts catalogue,
Boston, 1967, p.79
[3] Op.cit. p.79
[4] Dean Swanson, *Morris Louis: The Veil Cycle,* Minneapolis,
1977, Walker Art Center catalogue, p.24

PETER BLAKE b. 1932 'The Masked Zebra Kid' 1965

Assemblage-various media, 55.2 × 26.6 × 3.8 (21¾ × 10½ × 1½)

Although not the best known work by Peter Blake, the 'Masked Zebra Kid' contains many of the most interesting elements of his painting, and illustrates a variety of the techniques employed by him. The method of construction is typical of a group of works produced in the early sixties which take their imagery from popular culture, hence they belong to the mainstream of 'Pop Art'. In this case, the choice of materials has transformed the work, from what was essentially a scrapbook or collection of mementoes, into what can be regarded as a fetish object, suggesting the possession of primitive and secret powers. If we examine it more closely perhaps we will discover what lies behind the Zebra Kid's mask, or maybe we can invoke some of its sympathetic magic.

In part, the suggestion that this painting is a kind of totem derives from the observation that it is not a conventional picture framed in its own plane: it is a three-dimensional object which stands proud of the wall. Several devices have been used to produce this effect, the zebra being the most obvious, casting its shadow on the wall. The deep black frame pushing the plane of the painting forward and the juxtaposition of images, both photographic and lettering, add to this perception. Yet it is not sculpture.

The construction is quite elaborate. To begin with, Peter Blake made a soft wood supporting frame with a horizontal cross-piece half way up, and on this he attached a piece of plywood to the top half, and a piece of hardboard to the bottom half. He used panel pins which, since they were

hammered straight through the plywood from the front, are still visible despite the layers of paint. Next he applied green baize to the lower half, folding the edges round the sides of the hardboard, and onto this green baize he stuck collage

The reverse of the painting

material using double sided adhesive. In front of the collages Blake screwed a piece of slightly yellow acrylic sheeting (ICI Perspex). The top half consists of a portrait painted in acrylic medium on the plywood, and below this a thin batten, first

Peter Blake,
'The Masked Zebra Kid'
1965

painted in red gloss housepaint, (ICI Dulux or a similar alkyd type) then pinned horizontally to the front of the plywood. The red batten separates the portrait from the lettering 'Masked Zebra Kid' painted in the style of a fairground signwriter.

This construction is surrounded by a wooden frame (1½″ deep) also painted in gloss house paint, but in this case black. It has been pinned to the outside of the wooden supporting frame.

The artist then attached a Victorian toy zebra to the top edge of the black frame; the toy consists of a black and white print of a zebra stuck onto a shaped piece of wood and hand tinted in pale colours, (which may have since faded). The reverse of the toy has been glued onto a further piece of plywood and a wooden block, then screwed into position via the block.

A detail of the lower half

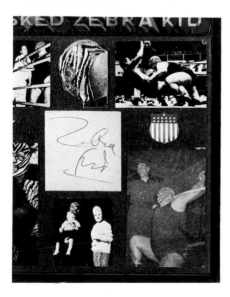

Some of the images in the collage, each portraying an aspect of the Zebra Kid, are taken from 'Boxing & Wrestling Illustrated' in standard magazine print on glossy paper, that is, carbon black on bleached wood pulp paper with added kaolin. The image on the bottom right is taken from a newspaper and is also on wood pulp paper. The stars and stripes (an image used in his Elvis self-portrait with badges) and the statue of liberty identify the American nationality of the Zebra Kid. The wrestler's autograph in the centre, a souvenir greatly prized by Blake, is probably the most significant piece.

This autograph was acquired at the stage door of the Commodore Cinema in Hammersmith following a bout, as the heavily-built wrestler was leaving wearing a gaberdine mackintosh yet still in his disconcerting mask. Pushing aside a small boy who asked for his autograph, he paused to sign Blake's paper, having recognised him as a fan from the crowd at previous fights. The wrestler then squeezed into a tiny Volkswagen and was gone. It is possibly this incident which inspired the work.

The head in the centre is a photograph of the Zebra Kid, embroidered by Jann Haworth, once again stuck down with double-sided adhesive onto the green baize. By setting it against the green baize, Blake has emphasised the real texture of the embroidery in contrast to the photographs of the texture of the zebra skin, koala bear fur and leopard skin pants.

The acrylic painting on the top half of the composition was brushed directly onto the plywood using relatively dark brown thinly applied acrylic as a priming to produce a dull overall tone in order to make the painting consistent with the degraded collage material. The portrait was intended only to be glimpsed, so was further toned down by Blake to reflect the enigmatic nature of the masked man.

This was a convenient device since Blake's normal technique of painting is slow and painstaking, but at the time he was under pressure to complete the work to comply with exhibition deadlines, so the painting was not as finished as the artist would have liked. The painting has since been varnished with acrylic gloss and is therefore more visible than intended.

All the collage material, and the toy, were old and, to some extent, deteriorated when first employed. The paper in the toy is stained by the resin from the wood; it is yellowed and scuffed. The embroidered head had been repeatedly bent during embroidery. Now, the newsprint is yellower, as is the autograph paper, which is also of poor quality. The magazine prints are almost certainly less intense than when new and the plywood is showing vertical splits as it slowly delaminates.

Although the work is constantly changing as the materials deteriorate, this was expected by Blake and is not considered to be of any serious consequence since the materials were chosen when already imperfect. Some further deterioration is quite acceptable and even if it were possible to bleach the paper or renew any of the elements, this would be to misinterpret the work. However, in order to reduce the rate of deterioration, a Perspex box has been made, with a background painted to match the walls. While remaining reasonably unobtrusive, this should protect the object, particularly the vulnerable zebra, but cannot entirely eliminate the slow changes that will occur.

But the work has been changed in ways of which the artist does not entirely approve. The original dull yellow piece of clear acrylic sheeting has been removed by a well-meaning but misinformed conservator and replaced with a new clear piece. This is an interesting case where a correct decision can be made only by fully understanding the aesthetic standards of the artist. Blake would have preferred to restore the original Perspex but since neither this nor a suitably similar piece has been found, the new piece remains. Fortunately this is not considered crucial by the artist. In a similar vein the acrylic portrait has been varnished to make it more visible. This is a much more serious problem since removing the varnish from an acrylic painting may prove to be extremely difficult. It is also of more general importance since many other modern paintings have not been varnished and were never intended to be. As is likely in this case, some areas would have been deliberately made glossy and others would have been matt where the paint has 'sunk'. The application of a general varnish although protecting the paint would hide these subtle differences.

Despite these reservations, the work still represents the original intentions of the artist; the many materials which make up the work have been chosen by the artist to portray the character of 'The Masked Zebra Kid'. At first collected only as random souvenirs, they were subsequently selected and arranged by Peter Blake to produce a potent image. As well as working within the formula developed in 'Tuesday' and the 'Fine Art Bit', the material here expresses a strongly felt personal enthusiasm for the subject, a genuinely innocent adulation. The crowning stroke of a toy zebra sitting outside the picture space is an unforgettable image.

SOURCES

Conversation with the artist.
Illustrated Catalogue of Acquisitions 1974-6, Tate Gallery, London, p.54

DAVID HOCKNEY b. 1937 'A Bigger Splash' 1967

Acrylic on Canvas, 242.5 × 243.8 (95½ × 96)

'A Bigger Splash' was painted sometime between April and June 1967 while Hockney was teaching at the University of California, Berkeley, U.S.A. The Splash is based on a photograph he found in a book on the subject of building a swimming pool, and the background is taken from one of his drawings of Californian buildings. In many of his paintings the subject matter is a composite of personally observed details and photographic images. He feels photographs do not in themselves contain enough information to draw from but they can be developed imaginatively or used as mnemonic devices. He does not aim to produce an exact replica of the photograph.

Discussing 'A Bigger Splash' in his autobiography Hockney describes his fascination with the depiction of such an ephemeral thing as a water splash. 'I loved the idea first of all of painting like Leonardo, all his studies of water, swirling things. And I loved the idea of painting this thing that lasts for two seconds: it takes me two weeks to paint this event that lasts for two seconds'[1].

The Splash was developed in three paintings. 'A Little Splash' (1966) was the first version, only 16'' × 20'' in size. This idea was enlarged and modified into 'The Splash' (1966). Unsatisfied with the background, which he felt was too complicated, he simplified the building and landscape in the final version 'A Bigger Splash' (1967). It is the largest of the three, 95½'' × 96'' in dimension, painted in Liquitex artists' acrylic emulsion paint on cotton duck canvas.

Cotton duck is used as a painting support by many modern artists because of its whiteness, cheapness and availability in large sizes. Most of Hockney's large pictures are painted on it.

Liquitex (Permanent Pigments Inc., Cincinnati, Ohio) is one of several water based acrylic emulsion paints available in America. It is completely different in chemical formula and paint formulation from the oil compatible, white spirit soluble acrylic, Magna, used by Morris Louis. Liquitex can only be diluted with water. The acrylic resin used in the paint is an ethyl acrylate/methylmethacrylate/methacrylic acid copolymer, tiny globules of which are suspended in water along with pigment, and the various additives required to produce a marketable liquid paint. When painted out, the water evaporates and the resin coalesces around the pigment particles forming a continuous film. Once dried the paint is insoluble in water so overpainting will not affect the underlying paint. The paint dries in minutes, if applied in thin glazes, or hours, if thick. In contrast oil paint, which dries by chemical change (oxidation and polymerisation of the linseed oil), takes days to become touch dry, and years to dry throughout. Once dry the acrylic colours retain their colour intensity, unlike oil where the yellowing of the medium affects the tone and hue. The Liquitex pigments have all been tested for light fastness and the medium is known not to yellow. Hockney liked their intense colours, as well as the fact that he could continue to work on one picture at a time rather than on three or four at once which the slow drying of oil paint necessitated. He had

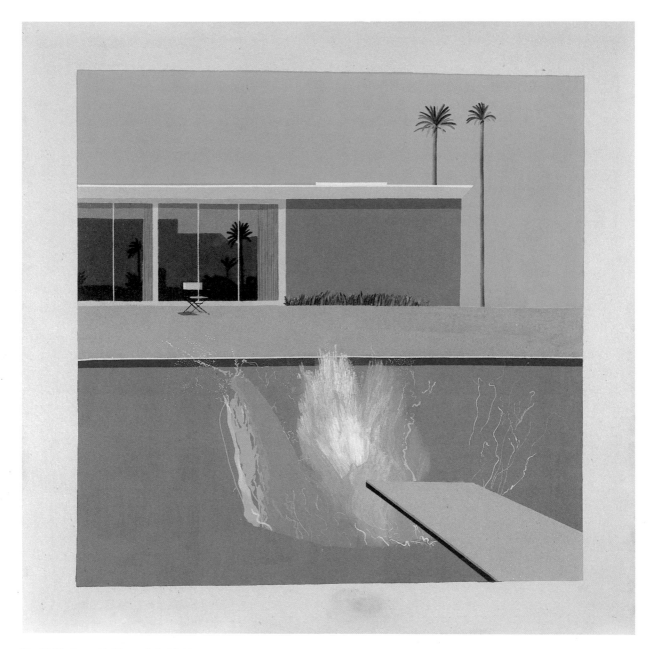

David Hockney, 'A Bigger Splash' 1966-7

tried acrylic in Britain but liked neither texture nor colour range of the paint available[2]. American acrylics had been manufactured for a much longer time and were more sophisticated. Hockney was greatly impressed by the acrylic paint he found in a Los Angeles art store when he moved there in 1963, and in fact gave up oils, using acrylic almost exclusively from this date until 1972. 'The clear light of California suggested simple techniques as the light in a London room suggested an older "chiaroscuro" technique.'[3]

Two painting techniques have been used in 'A Bigger Splash'. Firstly a masking technique and secondly the more traditional application of paint by brush. Describing the picture, Hockney says 'It's very strong Californian light, bold colour, blue skies. I rolled it on with rollers and the splash itself is painted with small brushes and little lines, it took me about two weeks to paint the splash'[4]. The colours used were cobalt blue, ultramarine blue, raw sienna, burnt sienna, raw umber, Hookers green, Naples yellow and titanium white. These were applied mixed together or as tints (i.e. colour plus white for the sky and pool blue). Hockney stapled the canvas to his studio wall while he painted it. Not all of the canvas was covered by paint, the thin strip running horizontally across the centre of the painting (acting as the pool edge), and the wide canvas border were left unpainted. A canvas border was a frequently used pictorial device in his work between 1964 and 1967 – 'It was a kind of concession to current art. It seemed to me that if I cut the picture off there, it became more conventional, and I was still a little frightened of that then'[5]. No preliminary drawing was done on the canvas. Hockney says he may have coated the area to be painted with Liquitex 'matte medium' but exact recollection of every detail of an artist's technique is not always possible

years after finishing the painting.

Thin strips of masking tape (a removable self-adhesive paper tape) were stuck onto the canvas to define the main shapes, and paint was applied within these areas by paint roller. The dark blue swimming pool and the sky were the first to be applied. Small blue paint splashes can be seen on the canvas where the paint has splashed over the outside edge of the masking tape strip. Each layer was allowed to dry for a couple of hours before taping the next area to be painted. Masking tape, once removed, gives very straight crisp edges to the painted area. These edges can be clearly seen in the raking light photograph. However, the unevenness of the canvas can make it difficult to stick the tape completely flat, and paint may seep under the tape edges. Such imprecise edges can be seen, for example, on the end of the spring board or on the pink wall of the building. The paint is applied very evenly in up to three thin layers with no impasto. The texture of the canvas can still be seen clearly through the paint in the raking light photograph. Large areas of paint can be applied quickly and evenly using the simple roller and masking tape technique. Some texturing will be present because the roller surface will imprint its texture into the paint, or more paint may be deposited in one area than another. Examples of this can be seen in the pavement below the palm trees, or in the sky. Once the main areas were laid in by roller the more detailed areas were painted on top with bristle and sable brushes. The trees, grass, chair, window (including the curtain and reflections) and of course, the splash are all painted by brush.

Acrylic paint can be applied straight from the container, with added medium (acrylic emulsion without pigment) or with medium diluted with water. A range of media (in emulsion form) are available which when added to the paint can make

it either matt or glossy, dilute it to a more liquid consistency, create textured effects, slow the rate of drying, and so on. It is important not to over-thin the paint with water alone. The acrylic resin and the pigment only wet each other during the drying process. If they have been spread over too great an area by adding too much water, there will not be enough resin to form a continuous film around the pigment particles, and the paint will look chalky, have little strength, be damaged by abrasion and generally have a much shorter lifespan than a properly formed paint film. This problem may also occur when painting on absorbent supports such as unprimed canvas. Hockney has mixed gel medium into his paint in 'A Bigger Splash' in proportions of 1 part medium to 4 parts paint. Gel medium thickens the paint. Hockney added it to improve the flatness in the rollered areas. He painted with Liquitex from both tube and jar containers. The blues are mainly jar colours because he used more blue at that time in his work. It should be noted that Liquitex jar colours are not in fact bigger pots of tube colour, but are formulated differently, with different thickening agents. Tube paint is thick and paste-like, retaining brush texture and handling like oil paint. Jar colour is easily thinned, flows well, retains little texture and is formulated for painting large flat areas, for example in colour staining, hard edge or spraying techniques. An under-standing of the effects of mediums and differences between paint formulations is of importance to all artists as it enables them to achieve desired effects without struggling with difficulties caused by inappropriate choice of materials.

A couple of points remain to be mentioned about 'A Bigger Splash' as we see it today. The image created by the painter has been modified by over fifteen years of environmental exposure and by the physical properties of the materials used.

The canvas border around the paint is no longer as white as it was when first painted. Canvas deteriorates on ageing, losing strength and becoming yellow and darkened. Tonal relationships between painted and unpainted areas will therefore change. Because it is exposed to light and air pollutants to a greater extent than the painted areas, the border will deteriorate more quickly. Bare canvas is also unprotected against dirt deposits and is readily soiled. Dirt can add images to the picture which are not intended by the artist. Examples are the dirty fingermarks along the edges of 'A Bigger Splash' and the rubbed stain on the canvas border (bottom centre edge). These marks are not always removable.

Canvas shrinks and swells with changes in relative humidity (amount of water vapour in the air). This movement is restrained by the presence of a painted layer on top. Looking at the raking light photograph, it appears that the painted area is slightly recessed into the canvas, like the impression made on paper by an etching plate. This is due to the slight shrinkage of the canvas during the application of the wet paint. The paint now holds it in this position while the surrounding unpainted canvas continues to move.

Canvas loses tension after stretching. Unpainted areas will slacken more than painted ones causing bulges. Some areas are held more firmly under tension by the staple attachments on the side turnover edges than others. This results in scalloped shaped bulges at the very edge of the painting. These distortions should not be confused with the round bulges which also appear in the photograph; two below the palm tree and several on the right hand side (centre). Fingers poking into the canvas from the back have caused the latter. This may happen when the picture is

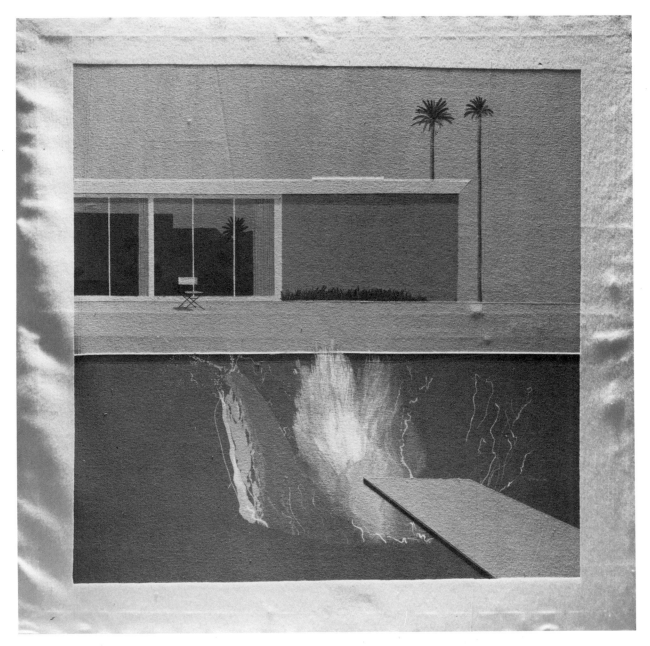

A raking light photograph showing the canvas texture and the contraction of paint on drying

lifted by the cross-bar. One other feature shown up in the raking light photograph is the distortion caused by the unbevelled edges of the stretcher and cross bar pressing against the canvas.

The fact that acrylic paint is less prone to crack than oil, does not yellow and involves pigments tested for lightfastness, would seem to make it the perfect choice for artists concerned with the longevity of their work. Unfortunately the slight softness of the paint at room temperatures can allow dirt, which settles on the painting, to become incorporated permanently into the paint film. Over a long period of time the bright colours will lose their intensity because of this dirt layer. Some acrylic varnishes will also be prone to this, and one obvious example is on Hockney's 'Mr and Mrs Clark and Percy', also in the Tate collection. Being of similar chemical composition to the paint, such varnishes cannot be removed without damaging the paint film. All painting materials have some defects and acrylic is no exception. However there are many positive points in its favour. It is water based, dries quickly with little odour, once dry can be immediately overpainted and can be used to achieve a whole range of traditional and modern painting techniques. In 'A Bigger Splash' one can see both a roller technique and a more tempera-like execution. Hockney continued painting in acrylic for several years after completing it but eventually returned to oil paint. He wished for a more naturalistic effect which was easier to achieve in oils because 'you can work for days and keep altering it as well; you can scrape it off if you don't like it. Once acrylic is down you can't get it off. It's that permanent.'[6]

[1] David Hockney, *David Hockney,* Ed. Nikos Stangos Thames and Hudson, London, 1976 p.124
[2] Rowney marketed their acrylic Cryla standard formula in September 1963. It was formulated to give a paint consistency like oil paint. Some artists and art students initially did not like it because it was too thick to use to emulate the thinned paint techniques they saw in contemporary American acrylic paintings. Rowneys therefore developed a second, more liquid flowing paint to be used for these techniques. This was Cryla Flow Formula. Both types are now very popular.
[3] Unpublished correspondence with Hockney, Tate Gallery Conservation Department questionnaire, 1982
[4] D. Hockney, *David Hockney,* Thames and Hudson, London, ibid. p.124
[5] D. Hockney op.cit. p.125
[6] D. Hockney op.cit. p.125

FRANK STELLA b. 1936 'Guadalupe Island, caracara' 1979

Mixed Media, 238.1 × 307.3 × 45.7 (93¾ × 121 × 18)

The 'Guadalupe Island, caracara' is quite different from the 'black paintings' Frank Stella was doing in the late 50s. With an increase of complexity in his work came a similar transformation of his materials and techniques[1]. Stella's exuberant use of bright gawdy colours and rich texture on complex supports, brought a lot of comment from critics. His colours have been described as coming from a 'para-industrial Disneyland'[2], and that 'Pop art in comparison is arty and restrained'. It has been presumed that his quest has been 'to marry the fully sculptural to the thoroughly painterly' but it has resulted in obscurity rather than clarity. When Stella was questioned on his recent work as to whether it had anything to do with sculpture he said, 'I always think of sculpture as something on the ground. As long as it's on the wall or has relief I don't think of that being particularly sculptural'[3].

The employment of a manufacturer to make his support was criticised as being the result of a large demand for his work. It was implied that this affected the quality of his work. But making the support for the full size versions from his maquette, involved specialist skills and facilities which Stella did not necessarily have, just as a sculptor may supply a maquette to the foundry where it is faithfully reproduced into a full size bronze or when a painter purchases a ready prepared canvas.

From earlier examples of his series of large relief works which lead up to the 'Guadalupe Island, caracara', Stella has carefully selected and modified the support to suit his particular needs. He began using conventional canvas supports but they tended to warp with the application of collage. He then marouflaged the canvas to 'Kachina Board' (heavy cardboard) reinforced with a removable strainer. In his 'Brazilian Series', begun in 1974, he used honeycomb aluminium for the first time.

The 'Guadalupe Island, caracara' began with a drawing on graph paper and was transferred into a working maquette made of foam board of approximately 1½ to 2 feet square. This was usually followed by the larger versions which were three times (3×) and five and a half times (5.5×) the size of the maquette.

Honeycomb aluminium was chosen as the best suited support for his larger works and is used exclusively in the 'Guadalupe Island, caracara'. This was a sound decision since honeycomb aluminium was developed for use in aircraft and satellites where strength and lightness are important factors. It is a very stiff material for its weight and its panel construction allows it to be cut, with a band saw, into any shape and still retain its stiffness. The honeycomb structure retains the panel in a flat plane during expansion and contraction with fluctuating temperatures. They are made in a variety of thicknesses and in the 'Guadalupe Island, caracara' it varies from ½ inch to 1½ inches. The twelve panels are bolted together with brackets and plates in order that they may be easily dismantled for transportation. The preparation of the aluminium surfaces is done by

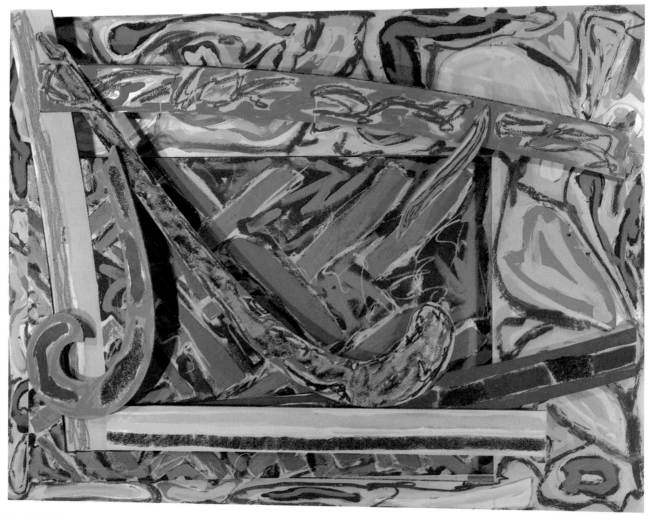

Frank Stella,
'Guadalupe Island, caracara' 1979

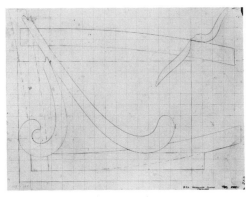

A preparatory drawing on graph paper

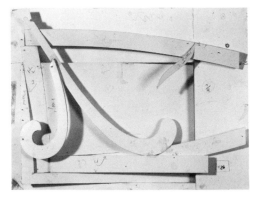

The working maquette

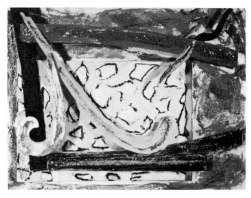

The maquette complete with the design layer

etching with a caustic solution. This is necessary because smooth aluminium is not a good surface to receive paint. Epoxy resin is then applied to protect the aluminium and ensure adequate adhesion of the paint films. Prior to, or during this preparation, some of the edges have 'U' channel aluminium inserted and some have the edges filled with glass fibre reinforced resin. The cutting and the construction of the support is by a company called 'Farmingdale L.I.'.

Each of the cut panels was painted separately and then the parts were assembled. Stella used a variety of paints which included lacquer based silk screen inks, Magna (white spirit based acrylic paint), Aquatec (water based acrylic paint) and Bocours Pearlescent White. These paints resulted in different types of application and varied from very fluid and runny areas to dry brushmarked calligraphic scribbles and thick creamy broad swipes. The calligraphic marks, in lithographic crayon and Magna, were mostly applied after the paint layers. Many areas of epoxy coated aluminium remain uncovered.

The texturing materials Stella used were ground glass, anodized aluminium glitter and reflective beads. They were applied in three ways: by sprinkling the material onto wet epoxy resin; by mixing the texturing material with some epoxy resin then applying the mixture to the support; by coating or fixing the texture material with epoxy resin or paint after initial application in the first or second method. These three methods have had varying degrees of success. The first method – used mostly with glitter – was the least successful as some of the material did not sufficiently embed in or adhere to the wet epoxy resin. After nearly two years from the date of acquiring 'Guadalupe Island, caracara' there is still some glitter falling off. If Stella had totally encapsulated the glitter in

A cross-section through the painting to show its construction

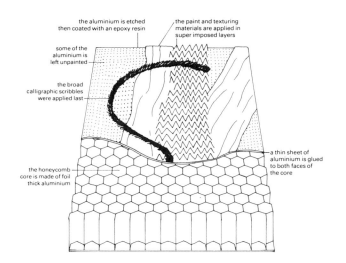

The reverse of the finished painting

resin it might have prevented any loss of material, but this would also have reduced the effect of the glitter. As with many techniques a compromise has to be made, as in this instance between the effect and permanence of attachment of the glitter. There must have been an acceptable amount of loss, for Stella said, when asked if the glitter should be replaced – 'No . . . within reason . . . unless a tremendous amount comes off . . . which is unlikely'.

Budd Hopkins aptly took a quote from Louis Armstrong who when asked who was the better jazz musician, Bob Hacket or Billy Butterfield, said, 'Bobby Hacket . . . he has more ingredients'. With 'more ingredients' more technical problems arise in making the work and the future stability of the image becomes less predictable.

[1] P. Leider, *Stella Since 1970,* Los Angeles, 1978, Fort Worth Art Museum catalogue pp.10-18
[2] B. Hopkins, 'Frank Stella New Work (A Personal Note)', *Art Forum,* Vol.15, No.4 Dec. 1976 pp.58-59
[3] Peter Rippon, T. Maloon and Ben Jones, 'Frank Stella Interview', *Artscribe,* No.7, London, July 1977 pp.14-17

A SELECTED READING LIST

This short list is intended as a small sample of the wide range of publications on the practice and study of the crafts of painting and the graphic arts.

It would be advisable to check the availability of current editions as a few are out of print.

HISTORY OF TECHNIQUE

Marjorie B. Cohn, 'Wash and Gouache: A study of the development of the materials of watercolours', The Centre for Conservation and Technical Studies, Fogg Art Museum 1977 (1st edit 1939)

W.G. Constable, *The Painter's Workshop,* Dover Publications Inc. 1979 (1st Edition O.U.P. 1954)

Sir Charles Lock Eastlake, *Methods of Painting of the Great Schools and Masters,* 2 vols (formerly titled: *Materials for a History of Oil Painting*), Dover Publications, Inc., New York 1960

Rutherford. J. Gettens & George L. Stout, *Painting Materials, A Short Encyclopaedia,* Dover Publications Inc. 1966 (1st edition Van Nostrand 1942)

R.D. Harley, *Artists' Pigments 1600-1835,* Butterworths, London 1970

Waldemar Januszczak, Editor, *Techniques of the World's Great Painters,* Chartwell Books Inc., London, 1980

A.P. Laurie, *The Painter's Methods and Materials,* Dover Publications Inc., New York, 1967

Raymond Lister, *Infernal Methods: A Study of William Blake's Art Techniques,* G. Bell and Sons Limited, London 1975

Mary P. Merrifield, *Original Treatises on the Arts of Painting,* 2 Vols, Dover Publications, New York, 1967

National Gallery Technical Bulletins, Published by Order of the Trustees, Publications Department, National Gallery, London from Number 1 1977 continuing.

F. Schmid, *The Practice of Painting,* Faber and Faber Limited, London 1948

D.V. Thompson, *The Practice of Tempera Painting Materials and Methods,* Dover Edition, New York, 1962 (1st Pub. by Yale University 1936)

D.V. Thompson, *The Materials and Techniques of Medieval Painting,* George Allen and Unwin, Ltd. London (Dover Edition 1956)

James Watrous, *The Craft of Old Master Drawings,* The University of Wisconsin Press 1957, U.S.A., 1975

TREATISES: ANCIENT AND MODERN

Thomas Bardwell, *The Practice of Painting and Perspective Made Easy,* London, 1756

Cennino Cennini, *Il Libro dell'Arte, The Craftsman's Handbook of Cennino d'Andrea Cennini,* Ed., Daniel V. Thompson, Dover Publications Inc., New York 1954

Max Doerner, *The Materials of the Artist,* Translated by Eugen Neuhaus, Hart-Davis, London, 1949

Fred Gettings, *Polymer Painting Manual,* Studio Vista, London, 1971

T.H. Fielding, *On Painting in Oil and Water Colours for Landscape and Portraits,* Ackermann and Co., London 1839

Colin Hayes, *The Complete Guide to Painting and Drawing Techniques and Materials,* Phaidon, London 1979

H. Hiler, *Notes on the Technique of Painting,* Faber and Faber Ltd. London 1934

Nicholas Hilliard, *A Treatise Concerning The Arte of Limning* Modernised text and edited by T.G.S. Cain and R.K.R. Thornton, Mid Northumberland Arts Group in Association with Carcanet New Press 1981

Ralph Mayer, *The Artists' Handbook of Materials and Techniques,* Faber & Faber, London, 1962

K. Wehlte, *The Materials and Techniques of Painting with a supplement on Colour Theory,* Van Nostrand Reinhold Co. English Edition 1975

PAINT TECHNOLOGY AND MATERIALS

G.P.A. Turner, *Introduction to Paint Chemistry and Principles of Paint Technology* Chapman and Hall, London, N.Y. 1980 (1st Edition 1967)

A.H. Church, *The Chemistry of Paints and Painting,* Seeley and Co. Ltd, London, 3rd Edition 1901

THE CARE OF PAINTINGS

George L. Stout, *The Care of Pictures,* Dover Publications Inc., New York 1975 (originally published 1948)

Helmut Ruhemann, *The Cleaning of Paintings Problems and Potentialities,* Faber and Faber, London 1968

Garry Thomson, *The Museum Environment,* Butterworths, London 1978

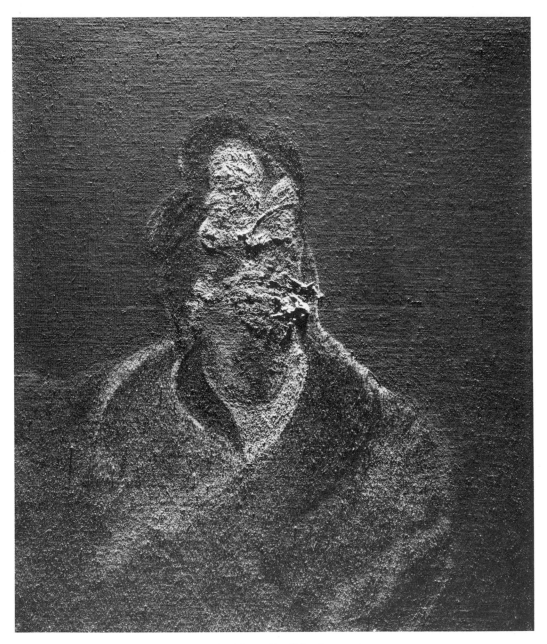

Francis Bacon, 'Portrait of Isabel Rawsthorne' 1966 A raking light photograph